IMAGES
of Rail

SUNNYSIDE YARD AND HELL GATE BRIDGE

Dec 16, 2016

Tabe:

Enjoy my book

David Morrison

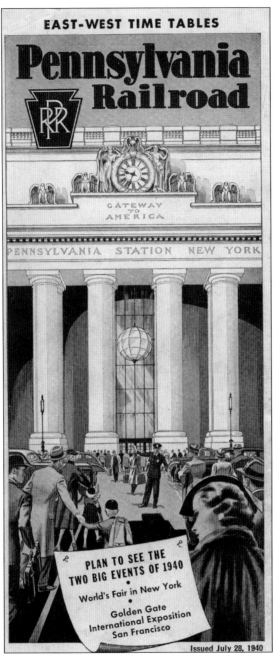

This July 28, 1940, Pennsylvania Railroad (PRR) timetable features a drawing of the main facade of Pennsylvania Station on the cover. The phrase "Gateway to America" was added to the drawing and was not actually on the building. The PRR was quite proud of its New York City passenger station. (Author's collection.)

ON THE COVER: Four New Haven Railroad class EF-1 electric locomotives power westbound freight train NG-1 through the east arch of Hell Gate Bridge on March 14, 1953. The train is headed toward Bay Ridge, where the cars will be transported by car floats to the Pennsylvania Railroad yard in Greenville, New Jersey. (Courtesy of Gene Collora.)

IMAGES
of Rail

SUNNYSIDE YARD AND HELL GATE BRIDGE

David D. Morrison
Foreword by Stephen F. Quigley

ARCADIA
PUBLISHING

Published by Arcadia Publishing
Charleston, South Carolina

Printed in the United States of America

Library of Congress Control Number: 2016938541

For all general information, please contact Arcadia Publishing:
Telephone 843-853-2070
Fax 843-853-0044
E-mail sales@arcadiapublishing.com
For customer service and orders:
Toll-Free 1-888-313-2665

Visit us on the Internet at www.arcadiapublishing.com

This book is dedicated to Ron Freeman, retired member of New York's Finest—the New York City Police Department. He left us too soon, but he is fondly remembered by his railfan friends on Long Island. (Courtesy of Sharon Freeman.)

CONTENTS

FOREWORD

The grandeur of New York's Pennsylvania Station is long gone, most likely never to be duplicated. However, the structures and facilities that were needed to fulfill the promise of Penn Station are with us today, with some changes. Hell Gate Bridge is still as magnificent as when it was built almost 100 years ago, and Sunnyside Yard is still a stopping and servicing point for countless trains each day. The Pennsylvania Railroad, which was the creator of these structures, is no longer in existence, but its successors, Amtrak and New Jersey Transit, have a substantial presence in Sunnyside Yard, and its importance is still being felt 100-plus years later. On the other hand, Amtrak and Metro-North both use Hell Gate Bridge many times each and every day. So the late, great, Pennsylvania Railroad and its creations are still with us today—in a modified fashion.

This book, written by David Morrison, tells the stories of the Hell Gate Bridge and Sunnyside Yard, as well as other structures and facilities, in pictures and words. Since Penn Station was the focal point for the design, construction, and implementation of Sunnyside Yard, Hell Gate Bridge, and all of its facilities, the station will receive appropriate coverage so that the reader will understand the importance of each piece of the puzzle and how each was related to the other.

Included in the story is other information about how this was all put together by the people of the Pennsylvania Railroad and how it is being used today. If a picture tells a thousand words, then the pictures presented in this book tell countless words about the history of key pieces in the transportation of millions of people in the Northeast each year and for the past 100-plus years.

—Stephen F. Quigley, president
Long Island Sunrise Trail Chapter, National Railway Historical Society

ACKNOWLEDGMENTS

First and foremost, I would like to thank John Turkeli, who has an extensive collection of archival material on Penn Station, Sunnyside Yard, and the Pennsylvania Railroad GG-1 locomotives. He is always willing to share his knowledge and collection with others. All of the unique Sunnyside Yard construction photographs in Chapter four are from Turkeli's collection, thus making that chapter most impressive.

Much appreciation goes to Stephen F. Quigley, who performed a meticulous editing of the text, as well as to James Mardiguian and John Turkeli, who reviewed the text for factual errors. Mardiguian also helped by providing his own photographs and those of the late Vincent Alvino.

Appreciation also goes to Gene Collora, Carl Dimino, Arthur Huneke, David Keller, Ray Kenny, Steve Lynch, George Povall, and Robert Sturm for contributing helpful information and images.

The books *The Late, Great Pennsylvania Station* by Lorraine B. Diehl and *The New York Connecting Railroad: Long Island's Other Railroad* by Robert C. Sturm and William G. Thom are excellent sources of information.

Caitrin Cunningham of Arcadia Publishing provided valuable input and guidance.

Finally, I want to thank my wife, Diane, who had the patience to see my project through to completion.

All images in Chapter three are from the author's collection except the last image.

INTRODUCTION

The title of this book implies that two subjects will be covered: the Sunnyside Yard and the Hell Gate Bridge. To understand the significance of both subjects though, the book will start by examining the need for the yard and the bridge—the New York Extension of the Pennsylvania Railroad. The centerpiece of the extension was Pennsylvania Station and its tunnels under the Hudson and East Rivers.

Pennsylvania Railroad president Alexander Cassatt (the brother of the famous impressionist painter Mary Cassatt) considered building a bridge across the Hudson River to get his railroad into Manhattan, but he decided instead to tunnel under the river. He was determined to build a massive station in Manhattan that would match or surpass the New York Central's Grand Central Station.

Cassatt realized that his plan for a New York City terminal would require a massive storage yard for the servicing of hundreds of passenger cars. Building the yard west of the terminal in the New Jersey Meadowlands was ruled out because it would require having to run trains westward back out of Penn Station, only to be returned again to the station. The decision was made to build the yard east of the station on Long Island.

Because the Long Island Rail Road owned a substantial amount of property in the Long Island City area, Cassatt decided to purchase that railroad. Such a purchase would allow the PRR to acquire tracks and property necessary to create the storage yard.

Before discussing Penn Station, railroading in the Long Island City area will be covered. There had been railroad facilities in Long Island City since 1854 (then owned by the Flushing Rail Road).

Chapter one will discuss the early steam locomotive era in Long Island City.

Chapter two will cover Penn Station and the tunnels serving the station. Sadly, the station building was demolished in the mid-1960s, but the Hudson River and East River Tunnels remain in active use.

Chapter three will cover the Long Island City Powerhouse that was opened in 1905 by the Pennsylvania Railroad to provide electric power for the New York Extension.

Chapter four will take a look at the construction of Sunnyside Yard. Once largely a swamp, this area of the Borough of Queens would be converted into the largest passenger car yard in the world.

Chapter five will deal with the operation of Sunnyside Yard. It was a place where trains that had finished their runs to New York City were taken to be inspected, serviced, cleaned, and prepared for their westbound runs out of Penn Station.

Chapter six will take a look at the Pennsylvania Railroad's famous GG-1 electric locomotives. These engines hauled passenger trains such as the *Broadway Limited* and the *Congressional* out of Penn Station for nearly 50 years. From 1934 to 1983, these engines were the predominant locomotives seen in Sunnyside Yard.

Chapter seven will cover the four signal towers that controlled the movement of trains throughout the area. These towers were the nerve center for trains entering, leaving, and passing through the yard. The safety of the entire yard operation rested upon the block operators and levermen who worked these towers.

Finally, Chapter eight takes a look at the Hell Gate Bridge. Completed in 1917, this bridge allowed New Haven Railroad trains to cross over the East River and enter New York City directly from Connecticut and the New England states. This bridge completed Cassatt's dream of the New York Extension.

The reader should bear in mind the enormity of the Pennsylvania Railroad's New York Extension. The project included construction of a monumentally large station building, built to last hundreds of years; two tunnels under the Hudson River and four tunnels under the East River; and an electric power generating plant, the size of which matched that of major electric power utility companies. The huge passenger car yard covered an area two miles long by 1,500 feet wide. A steel arch bridge was built to accommodate four tracks, with a deck 350 feet above the East River. In short, this was a massive project.

What makes this project significant is that it was financed entirely by private funding. The Pennsylvania Railroad paid for everything, except for sharing the cost of the Hell Gate Bridge with the New Haven Railroad. Today, it is hard to imagine such a massive project being accomplished with only private funding and no government assistance.

This private funding was made possible because in the early 1900s, America's railroads enjoyed fabulous wealth. Railroads were the sole means of transporting passengers long distances in a reasonable amount of time. Airplanes did not get off the ground until the Wright brothers' 1903 flight, and then it would be decades before commercial aviation became practical. Automobiles were in their infancy and were not reliable for traveling long distances. And even if they were up to the task, there were no roads to accommodate vehicles traveling long distances. Railroads were "the only act in town."

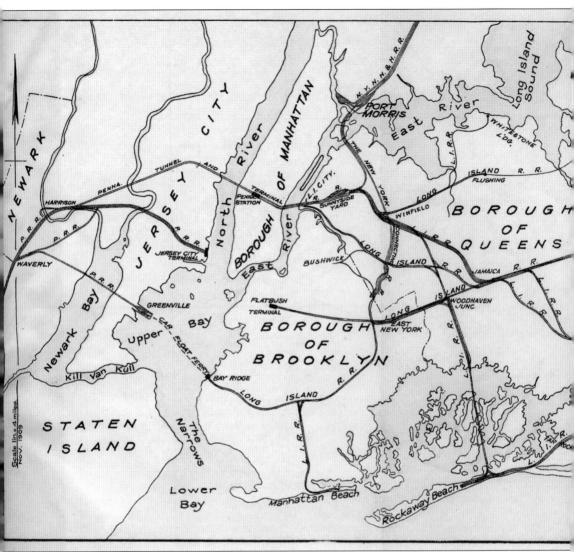

This map issued by the Pennsylvania Railroad in November 1909 shows the proposed route of the New York Extension when it would be completed in 1917. Penn Station lies within the Borough of Manhattan. The tunnels under the East River lead to Sunnyside Yard, as well as the Long Island Rail Road main line. A short distance east of Sunnyside Yard, a set of tracks diverge to the north, leading to Hell Gate Bridge. The scope of this book will concern the railroad from Penn Station through Sunnyside Yard to Hell Gate Bridge. Note that the Hudson River is labeled the North River here. (Author's collection.)

One

EARLY RAILROADING IN LONG ISLAND CITY

The Long Island Rail Road came to Long Island City almost as an afterthought.

—Ron Ziel

The Long Island Rail Road (LIRR) was chartered on April 24, 1834, and ran its first train between the Brooklyn waterfront and Jamaica in 1836. The railroad extended east, reaching Greenport in 1844. On the west end, ferryboats carried passengers from Manhattan's South Ferry to Brooklyn, and on the east end, ferries carried passengers from Greenport to Stonington, Connecticut. This completed the route of the Long Island Rail Road as was stipulated in the charter.

In 1859, Brooklyn banned the use of steam locomotives on local streets. The LIRR was no longer able to run steam trains along Atlantic Avenue. The tracks became a horse-car operation, which was most inefficient.

In 1860, the LIRR constructed a new line passing through Woodside to a new western terminal in Long Island City. Here, ferryboats carried passengers across the East River to James Slip, East Seventh Street, and East Thirty-fourth Street in Manhattan.

A station building, platforms, and yard and maintenance facilities were established, and a ferry terminal was opened on the waterfront. Operations were set up to carry farmers' horses and wagons across the river and back on the same day. Long Island City had become a bustling railroad facility, serving both passenger and freight trains.

The passenger station was opened at Hunters Point Avenue in 1860. It was renovated in 1878 but burned down on December 18, 1902. On April 26, 1903, a new station building opened, and terminal capacity was increased from 16 to 21 tracks.

The servicing of steam locomotives required an engine house, coal tower, water tank, and turntable. The Long Island City facility was no small operation.

Long Island City remained the LIRR's main western terminal until Penn Station was opened in 1910. Even so, it was not until March 3, 1925, that ferry service was abandoned. In 1939, the station building was demolished to make room for construction of the Queens-Midtown Tunnel.

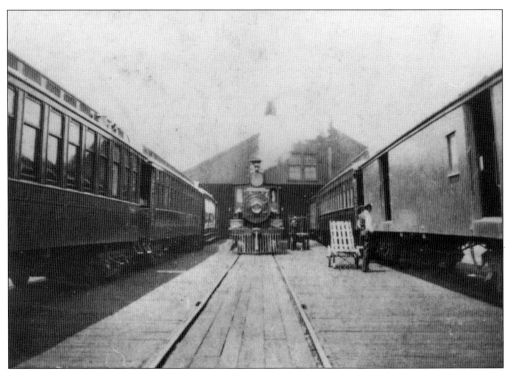

This 1888 photograph at the Long Island City Station shows a steam locomotive on a track that was covered with planking laid perpendicular to the ties, to allow easy walking across the active tracks. The baggage/express car at right has its doors open, ready to receive or discharge items. Wooden parlor cars are at left. (Author's collection.)

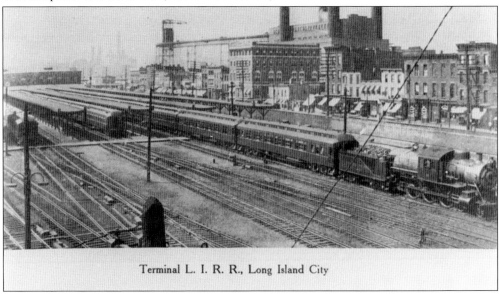

Terminal L. I. R. R., Long Island City

This 1908 photograph taken from the signal tower shows a camelback steam locomotive pulling a passenger train out of the Long Island City Station. The platform canopies can be seen covering some of the 21 station tracks. The powerhouse can be seen in the background. The large building in front of the powerhouse is the YMCA. (Author's collection.)

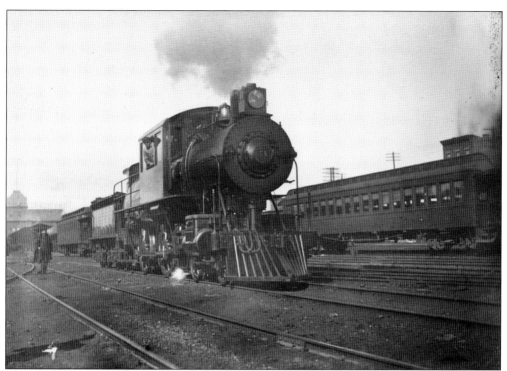

LIRR camelback Locomotive No. 54 is pulling a passenger train out of the Long Island City Station in 1899. This locomotive was of the 4-4-0 type built by Baldwin Locomotive Works. The station building can be seen in the left background. A wooden passenger car is at right. (Author's collection.)

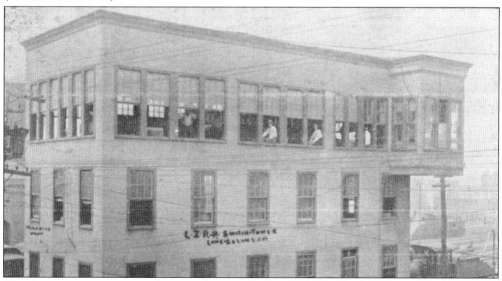

This four-story signal tower, designated Tower A, opened on November 6, 1904. Previous to its opening, all switches for the 17 station tracks and seven express house tracks were controlled by switch tenders working on the ground, who manually threw the switches. The tower had a 167-lever electro-pneumatic machine that replaced dozens of switch tenders. The tower was located east of the terminal. (Courtesy of John Turkeli.)

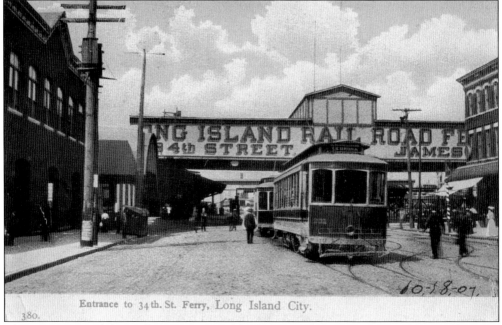

Entrance to 34th. St. Ferry, Long Island City.

This 1907 postcard shows the entrance to the Thirty-fourth Street Ferry at the foot of Borden Avenue in Long Island City. The LIRR terminal building is to the far left. Just beyond the terminal building, a curved canopy can be seen. This canopy allowed people to walk under cover from the elements between the terminal building and the ferry entranceway. Electric trolleys provided additional service to the ferry terminal. (Author's collection.)

The Long Island City terminal building was destroyed by fire on December 18, 1902. Unfortunately, the railroad's records and archives were stored in the building, and they also went up in flames. This 1914 view shows the rebuilt terminal building that opened on April 26, 1903. The powerhouse is in the left background. (Author's collection.)

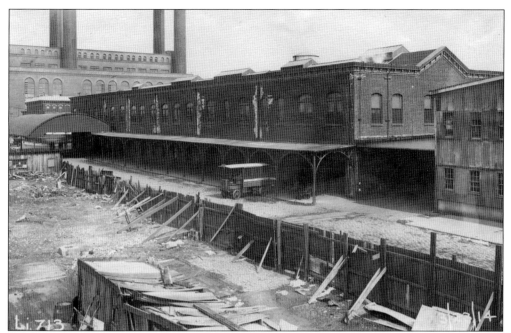

This 1914 photograph gives a good perspective of the railroad terminal in relation to the powerhouse. This view faces north toward Borden Avenue with the powerhouse in the distance. An early motorized vehicle can be seen backed up to the terminal building. The express house is to the right. (Author's collection.)

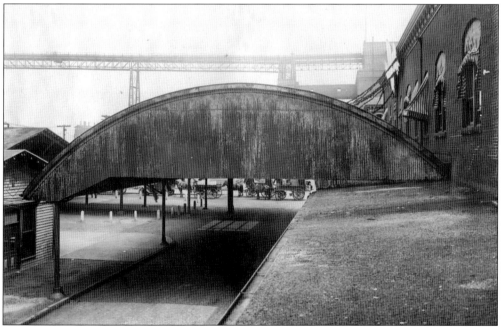

This June 23, 1919, photograph shows a close-up view of the canopy between the railroad and ferry terminals. Just below the canopy, horse-drawn wagons can be seen on Borden Avenue. In the distance, the coal conveyor for the powerhouse is visible. At right, awnings protect windows on the west side of the terminal building. (Author's collection.)

There was nothing fancy about the express house. This two-story structure was sheathed with corrugated tin on all sides. The sign above the door reads "Adams Express Company." The street sign indicates that this is the corner of Flushing (closest to camera) and Front Streets (going off to the left). The Adams Express Company later became part of the Railway Express Agency (REA). (Author's collection.)

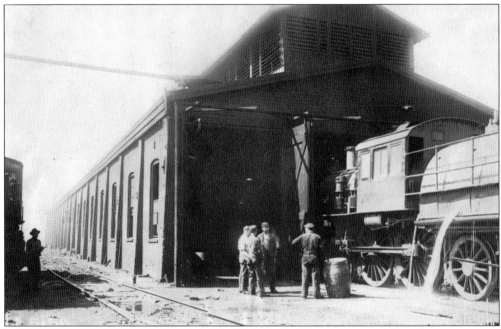

These railroad men are standing outside a two-stall engine house at Long Island City. The raised structure on the roof allowed for venting of steam locomotive exhaust smoke. Maintenance and light repairs were performed at this and another engine house at Long Island City. Engines in need of heavy repair were sent to the Morris Park Shops in Jamaica. (Author's collection.)

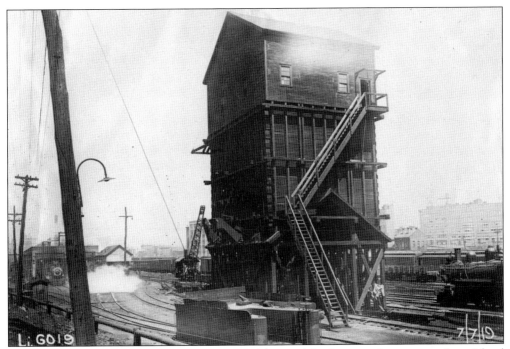

An essential part of a railroad operation was supplying coal for the steam locomotives. Long Island City had two wood coaling towers, which fed coal by way of chutes into the locomotive tenders. This is the smaller tower, with the coal chutes visible on the left side. In the distance at left, an engine house can be seen. (Author's collection.)

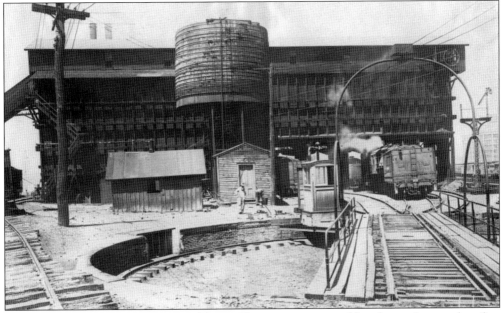

The larger coaling tower is pictured here. This tower was capable of providing coal to five locomotives at the same time. The conveyor that carried coal to the top of the tower is at left. A water tank is in front of the tower, and an electrically operated turntable is in the foreground. The turntable control cabin is at the far end of the turntable. (Author's collection.)

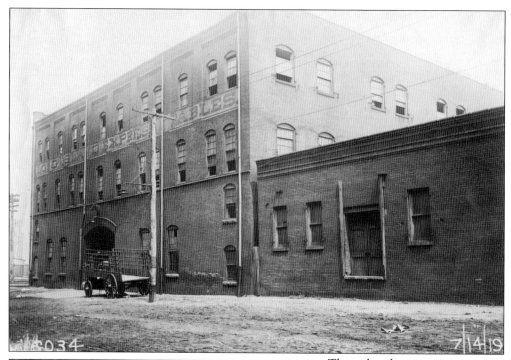

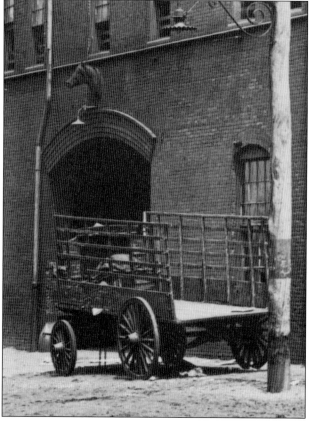

The railroad express service required a large number of horses, and naturally, the horses needed a stable. This July 14, 1919, photograph shows the size of the Long Island City express stable. The sign on the building reads, "Long Island Express Stables." After 1913, the express service was surrendered to the Adams Express Company, but the building sign was obviously not changed. At left is an enlargement of the main doorway area showing the horse head sculpture over the arch. (Author's collection.)

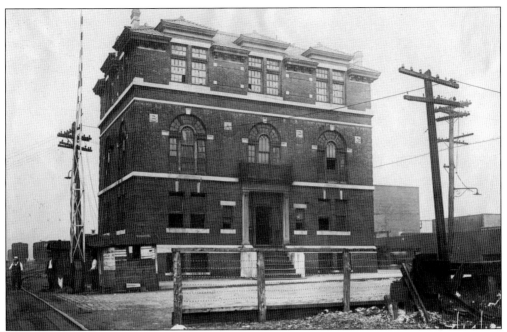

A railroad freight operation requires a lot of paperwork; for example, bills of lading, less-than-carload shipments, and per diem car storage rates and billing. This three-story building was the home of the Long Island City freight department. This July 14, 1919, photograph highlights the building's architectural details, especially the arched windows of the second floor. (Author's collection.)

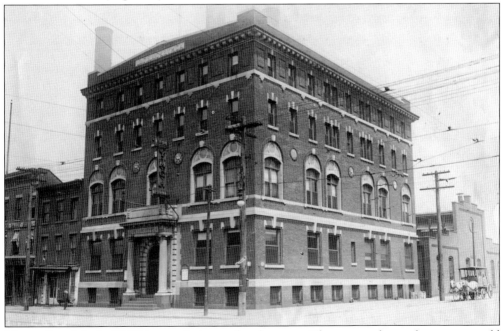

Most railroads had a YMCA near their crew headquarters. These were places where crews could find a bed between assignments. The athletic and entertainment facilities inside provided an alternative to a visit to the local taverns to belt down a few before the next train. The LIRR wagon repair shop can be seen in the right background. (Author's collection.)

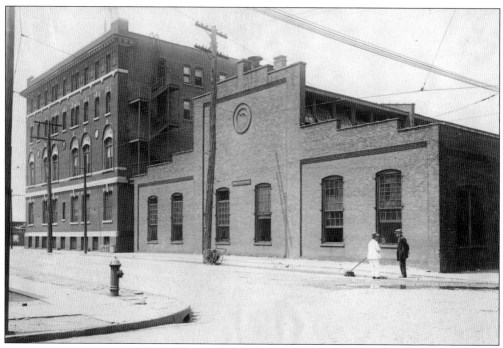

A sanitation worker dressed in white and holding a broom is talking to a man outside the LIRR wagon repair shop. His debris cart can be seen next to the utility pole. To the left is the YMCA building. Note how clean the street appears. (Author's collection.)

Here is one of the LIRR's horse-drawn wagons at the East Thirty-third Street express building in New York City. The horses and wagons were transported across the East River by ferryboats. In the early 1900s, the LIRR transported large amounts of horse manure collected off the city streets to the farms of Long Island to be used as fertilizer. (Author's collection.)

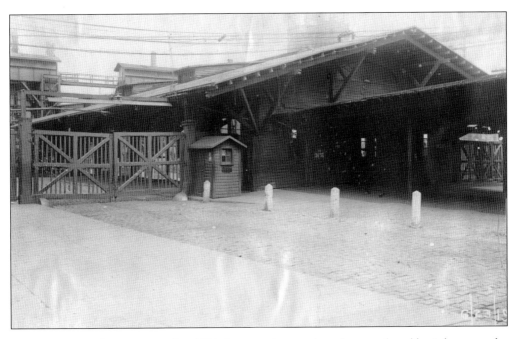

Even after Penn Station opened in 1910, ferry service continued on a reduced basis between the Long Island City ferry terminal, located at the foot of Borden Avenue, and the Thirty-fourth Street New York City ferry house. Seen above, the Long Island City facility was a wooden structure with extended canopies. Below, the Thirty-fourth Street facility was a rather substantial brick building. Stairs at right led to Second and Third Streets' elevated trains. The advertising sign at right is for ZuZu Ginger Snap cookies. (Both, author's collection.)

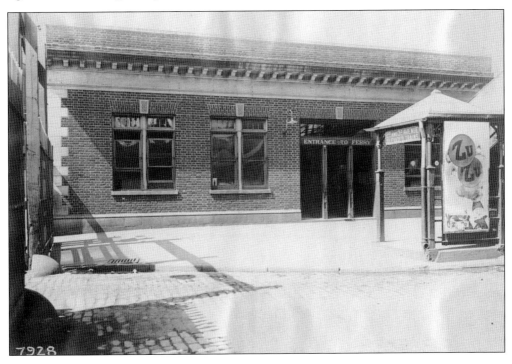

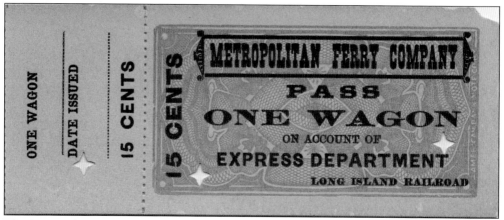

The Metropolitan Ferry Company was formed in 1887 to provide ferry service between Long Island City and James Slip in New York City. In 1892, the LIRR took over the ferry operation. This ticket was good for one wagon for 15¢. This ticket is undated, but it does have three punched holes and is brown with age. This is probably a genuine ticket and not one of the infamous LIRR reproductions from the early 1970s, when the LIRR sadly reproduced numerous tickets, timetables, posters, and passes without indicating that the items were reproductions. (Author's collection.)

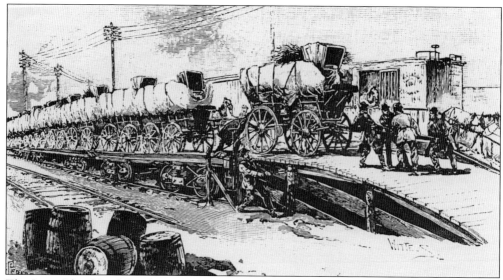

The Long Island Rail Road is said to have been the first railroad in the country to provide piggyback service. In this 1880s woodcut, farmers' wagons are being loaded onto LIRR flatcars for rail transportation to Long Island City, where they would be unloaded and placed onto ferries to transportation to New York City. Horses were loaded into livestock cars, as seen in the right background. (Author's collection.)

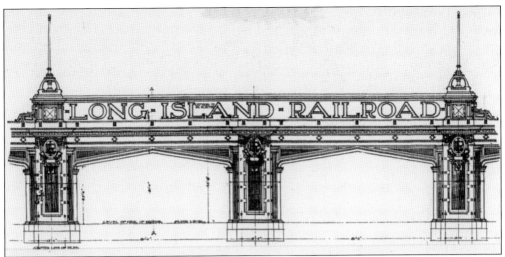

Oddly, while the tunnels were being dug under the East River to give the LIRR direct access into Manhattan, the railroad was drawing plans for a new ferry terminal at Thirty-fourth Street. This drawing, which appeared in the May 1907 issue of *Architects and Builders* magazine, was produced by architect Kenneth M. Murchison showing the proposed terminal. This structure was never built. (Author's collection.)

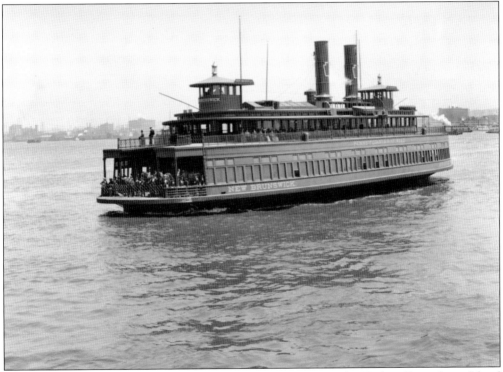

This is the Pennsylvania Railroad ferry *New Brunswick* crossing the Hudson River. Long Island Rail Road ferries such as this crossed the East River between Long Island City and Manhattan. The PRR did its best to make the river crossings as timely and comfortable as possible for the passengers, but often, weather conditions made the crossings burdensome. It was not until March 3, 1925, that railroad ferry service across the East River was abandoned. (Author's collection.)

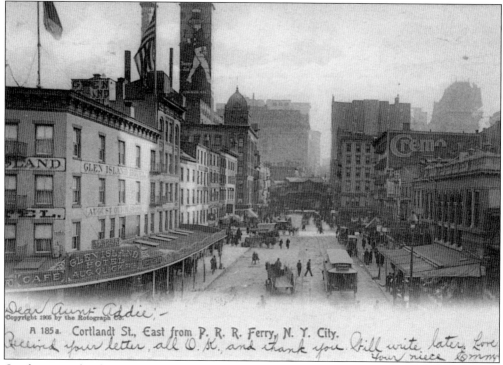

Dear Aunt Addie;—
Copyright 1906 by the Rotograph Co.
A 185 a. Cortlandt St., East from P. R. R. Ferry, N. Y. City.
Received your letter, all O. K., and thank you. Will write later, Love
Your niece Emma

On the west side of Manhattan, the Pennsylvania Railroad provided ferry service to bring people to Jersey City, New Jersey. These postcard scenes show the appearance of Manhattan prior to the opening of Penn Station. The photograph above shows Cortland Street, as seen from the PRR ferry terminal. Below is West Street, with the ferry terminal in the left background. In both views, the streets are quite jammed with wagons, horse teams, trolley cars, and pedestrians. A pedestrian bridge was eventually built, which can be seen at left below. (Both, courtesy of John Turkeli.)

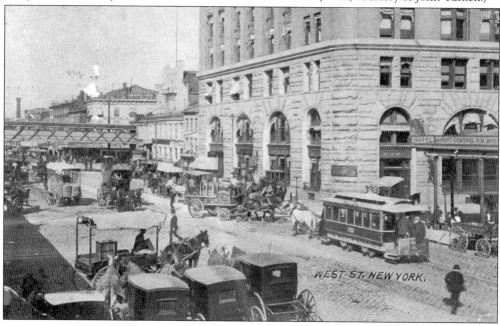

WEST ST. NEW YORK.

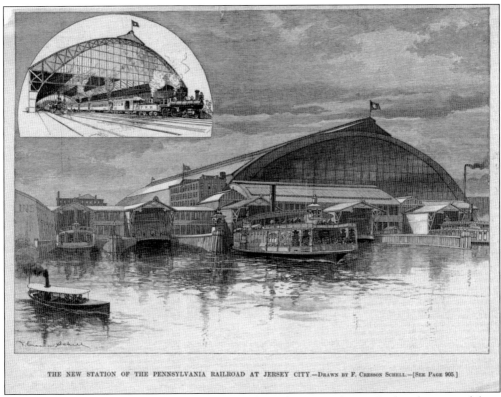

THE NEW STATION OF THE PENNSYLVANIA RAILROAD AT JERSEY CITY.—Drawn by F. Cresson Schell.—[See Page 905.]

Across the Hudson River in pre–Penn Station days, the Pennsylvania Railroad train and ferry terminal was at Exchange Place in Jersey City. The woodcut above shows the 1891 terminal with its high-arched train shed that accommodated 12 tracks. The terminal was destroyed by fire and replaced with a new one in 1898. The postcard below shows that the new terminal had a huge Pennsylvania Railroad sign over the arch that could be seen from Manhattan. (Both, author's collection.)

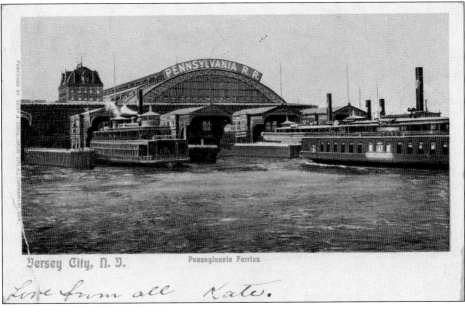

Jersey City, N. J. Pennsylvania Ferries

Love from all Kate.

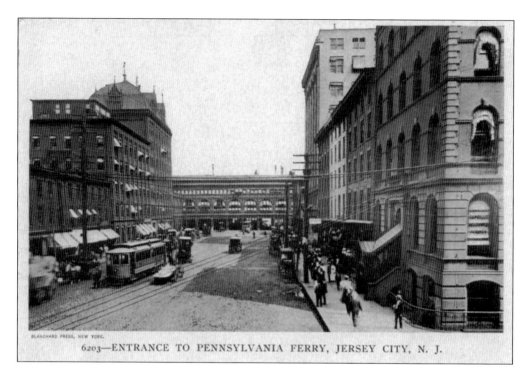

6203—ENTRANCE TO PENNSYLVANIA FERRY, JERSEY CITY, N. J.

These two postcard views show the street side of the Exchange Place terminal. The Pennsylvania Railroad did its best to make this facility attractive, going to the extent of covering the facade with ornamental copper. Train passengers arriving here in elegant Pullman cars would have to get on a ferry with everyone else leaving Jersey City to go to Manhattan. (Above, courtesy of John Turkeli; below, author's collection.)

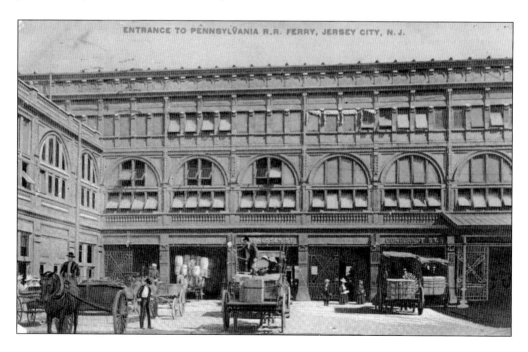

ENTRANCE TO PENNSYLVANIA R.R. FERRY, JERSEY CITY, N. J.

Two

PENNSYLVANIA RAILROAD'S NEW YORK EXTENSION

Today, it is inconceivable that a building of such grandeur, a building that bore witness to so much of our nation's history, could be wiped away so capriciously.

—Lorraine B. Diehl, *The Late, Great Pennsylvania Station*

The two largest competing railroads serving New York City in the late 1800s were the New York Central Railroad and the Pennsylvania Railroad. The former had direct access into Manhattan, the heart of the city, since 1871. The Pennsylvania Railroad had to terminate trains at Jersey City, New Jersey, where passengers would transfer to ferries to cross the Hudson River to Manhattan.

When Alexander J. Cassatt took over the PRR presidency in 1899, he was determined to find a way to bring his trains directly into Manhattan. He put into place a plan to build tunnels under the Hudson River as well as a huge station building in midtown Manhattan. Being that the New York Central Railroad had a grand station building on Forty-second Street, Cassatt wanted the PRR building to be just as extravagant. In the words of railroad historian Ron Ziel, "Penn Station was designed to last 800 years before major structural work would have been necessary." Sadly, the building was demolished in the mid-1960s, in what the *New York Times* called "a monumental act of vandalism."

Part of Cassatt's plan required a large passenger car storage yard where trains could be inspected and serviced for their return westbound trips, and thus evolved Sunnyside Yard.

Another part of Cassatt's plan involved linking the PRR with the New Haven Railroad to form a railroad connection from Penn Station to the New England states. This plan required that a bridge be constructed from New York to Connecticut across the East River, and thus evolved the Hell Gate Bridge.

The purpose of Sunnyside Yard and the Hell Gate Bridge was to make Penn Station a workable facility. This chapter will take a look at Penn Station.

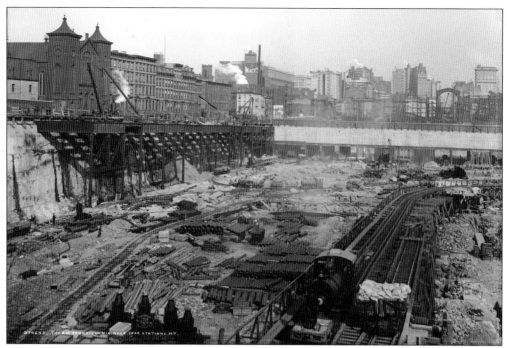

The excavation work for constructing the Hudson River (North River) tunnels that surfaced on the Manhattan side and for the huge Penn Station building required the demolition of over 500 buildings, covering 28 acres of land. Land purchases began in November 1901, and the first building was demolished on February 25, 1903. The above 1908 photograph shows the excavation site looking east. The white structure across the tracks is the viaduct to support Eighth Avenue. The shell of the station building can be seen in the distance. Below is a 1909 photograph showing the construction of retaining walls that lined the perimeter of the excavation site. (Both, courtesy of the Library of Congress.)

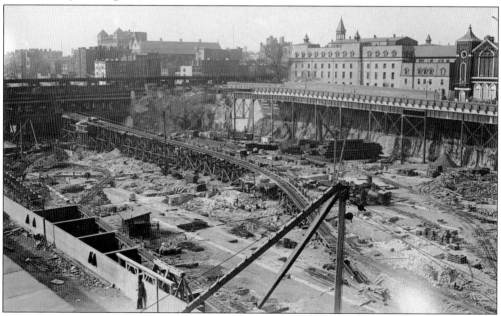

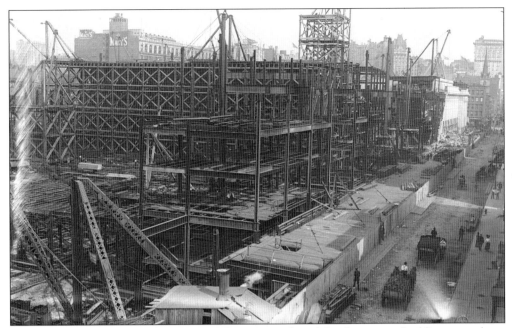

The design, fabrication, and erection of the structural steel for the station building was a huge undertaking. Over 13,000 drawings were produced for the steelwork alone. The design work commenced in 1902 and was not complete until December 1908. Erecting the building began in May 1907 and was substantially completed in September 1909. These two photographs were taken in October 1908. Macy's department store was located northeast along Thirty-fourth Street and is seen above in the left background. Below, the main facade along Seventh Avenue is seen under construction. (Both, courtesy of the Library of Congress.)

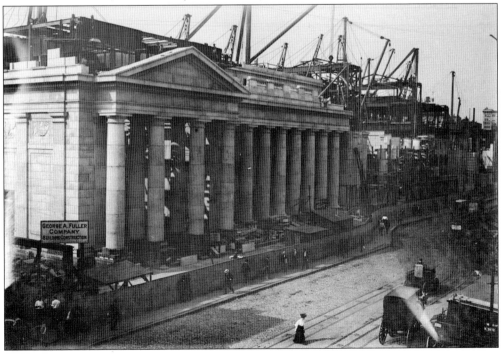

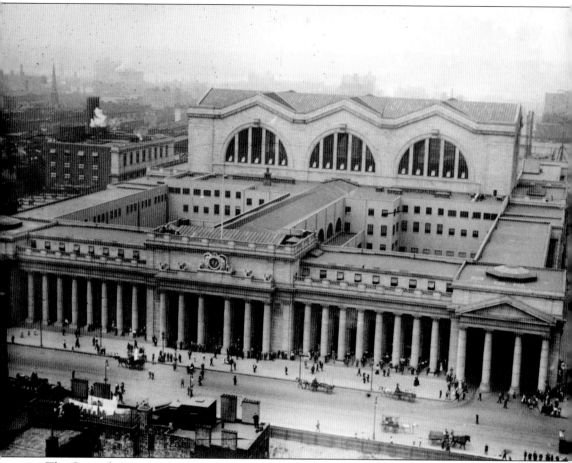

The Seventh Avenue front entrance of the newly opened Penn Station is seen here. This photograph was taken from the roof of the Gimbels department store, with Thirty-third Street to the right. The elevated portion toward the rear of the building is the main waiting room. In the foreground on the near side of Seventh Avenue is the property where the Pennsylvania Hotel would be built. (Author's collection.)

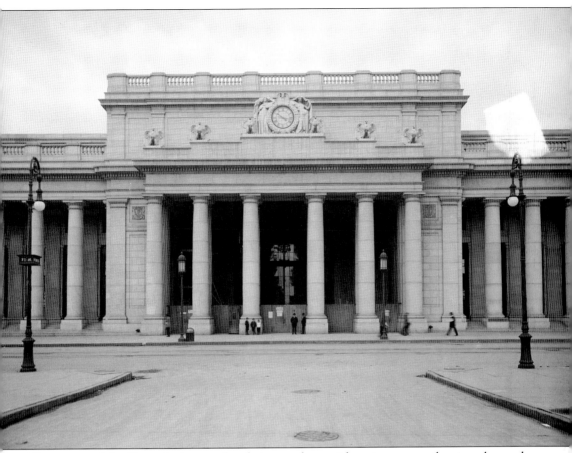

The center of the Seventh Avenue facade is seen here with statuary over the six-columned entranceway. The stone for the building was pink granite from Milford, Massachusetts, and the statuary was carved from marble. The sculptor was Adolph Weinmann. (Courtesy of the Library of Congress.)

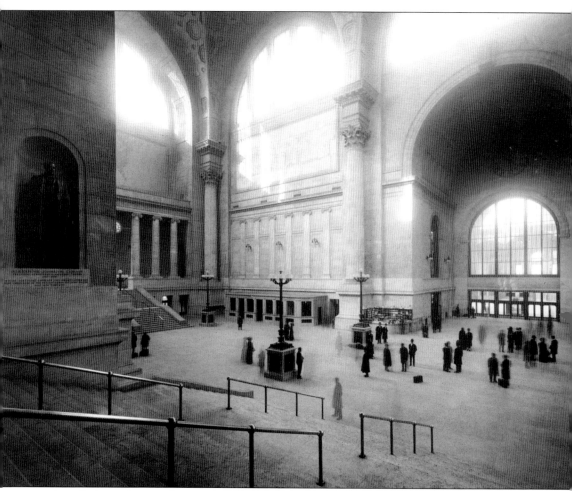

A walk down the grand stairway revealed the main waiting room of monumental proportions. The room was 109 feet wide and 315 feet long, and the ceiling was an awesome 150 feet high. The arched windows provided natural light to enhance the beauty of the travertine marble. To the left was a statue of Alexander Cassatt. Opposite Cassatt and out of view was a similar statue of Samuel Rea. The Rea statue is now on display outside the Seventh Avenue Madison Square Garden entranceway. (Courtesy of the Library of Congress.)

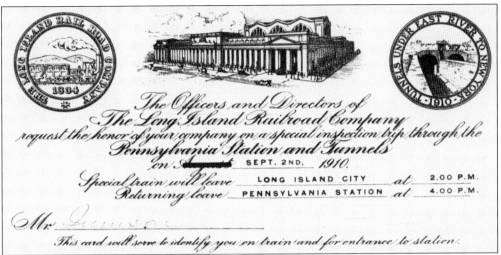

The Officers and Directors of
The Long Island Railroad Company
request the honor of your company on a special inspection trip through the
Pennsylvania Station and Tunnels
on ~~August~~ SEPT. 2ND. *1910*.

Special train will leave LONG ISLAND CITY at 2.00 P.M.
Returning leave PENNSYLVANIA STATION at 4.00 P.M.

Mr. _____

This card will serve to identify you on train and for entrance to station.

On September 2, 1910, a train carrying railroad officials and public dignitaries made an inspection tour of Penn Station. The Hudson River Tunnels were not yet ready, so a Long Island Rail Road commuter train made the trip from Long Island City through the East River Tunnels for the tour. This commemorative ticket was issued to celebrate the event. (Author's collection.)

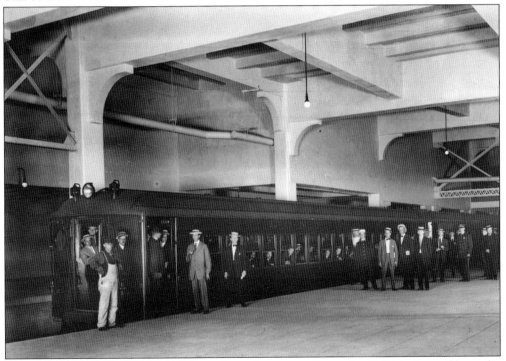

The first revenue passenger train departed Penn Station on September 8, 1910. Pictured here, the train was ready to depart for Jamaica Station where a celebration took place. The engineer is the man in coveralls standing outside the head end of the train. This day was referred to as "tunnel day," and trains were dispatched out of Penn Station to various LIRR stations during the day. A look at the brightness of the ceiling and columns illustrates the newness of the facility that day. Ironically, Pennsylvania Railroad trains did not leave Penn Station through the Hudson River Tunnels until nearly two months later, on November 27, 1910. (Courtesy of John Turkeli.)

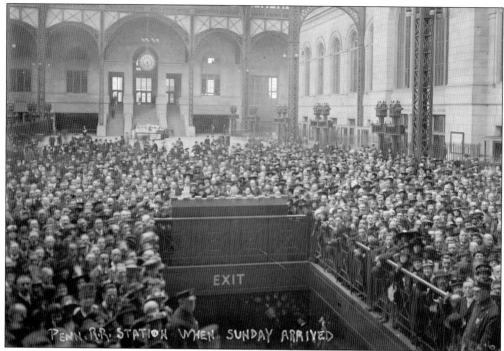

The Pennsylvania Railroad picked a Sunday to officially open Penn Station for trains using the Hudson River Tunnels. On November 27, 1910, over 100,000 people visited Penn Station to watch the arrival and departure of PRR trains. In this photograph, a large crowd is on the concourse to watch the trains down below at platform level. (Courtesy of the Library of Congress.)

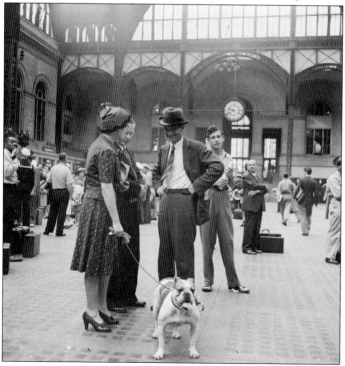

The dog seems to be the center of attention in this World War II–era photograph taken on the concourse. The floor was constructed using vault lights (commonly known as glass blocks), which allowed light to filter down to the train platforms below. (Courtesy of the Library of Congress.)

As a train conductor walks downstairs, three sailors climb the stairs with their bags in hand. Over 100 million troops rode the nation's trains yearly during World War II. Canteens and USO lounges for servicemen were located at all of the major railroad stations. (Courtesy of the Library of Congress.)

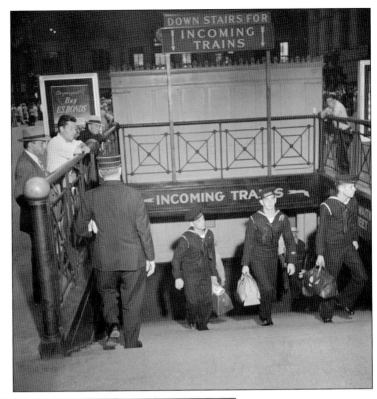

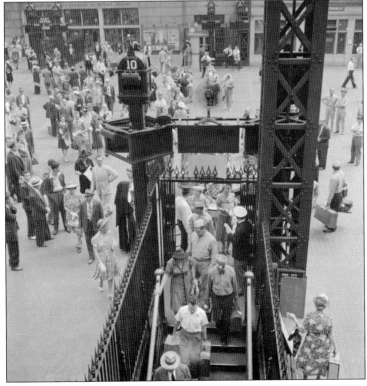

This 1942 photograph shows how open the stairways were that led from the concourse level down to the train platforms. The stairway railing, including the knobs, were made of brass, and they were polished every day. Some of these brass railings are still present today, although all of the stairways have been enclosed. (Courtesy of the Library of Congress.)

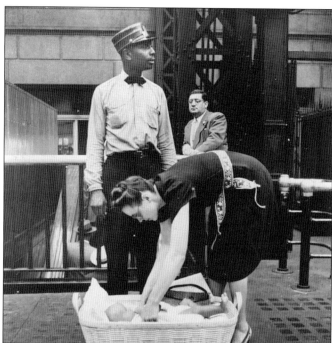

As this woman attends to a baby, the station attendant looks like he does not know quite what to do. All of the attendants wore red hats and were commonly referred to as "redcaps." They were often the first railroad employees seen by the traveling public, and they presented a fine image for the railroad. (Courtesy of the Library of Congress.)

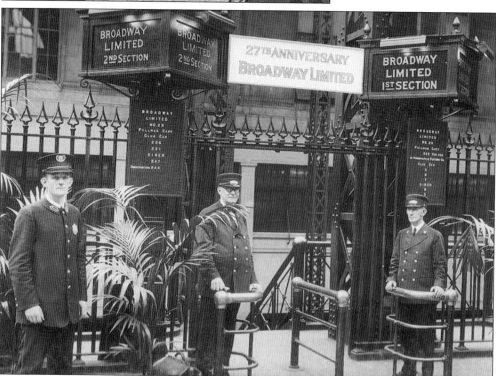

The *Broadway Limited* was the premier train of the Pennsylvania Railroad. It was inaugurated in 1902 as an all-Pullman sleeping car train, intended to compete with the New York Central's *20th-Century Limited*. In this 1929 photograph, the banner between the train indicators advertises the 27th anniversary of the train. (Author's collection.)

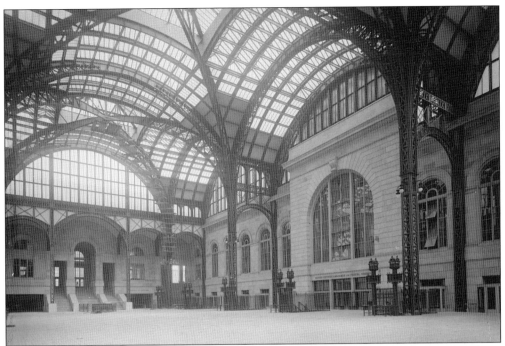

The entire ceiling of the concourse was basically a large skylight. The arched steelwork, or steel-framed vaults, supported hundreds of glass panels. The concourse was designed to allow an abundance of light. Furthermore, the glass-block floor allowed sunlight to reach the train platforms below. (Courtesy of the Library of Congress.)

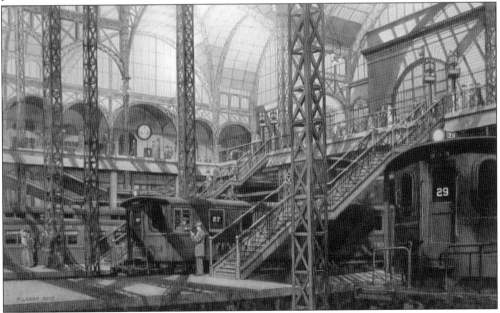

In 2010, to commemorate the 100th anniversary of Penn Station, artist Peter Lerro painted Pennsylvania Railroad DD-1 electric Locomotive No. 27 as it was ready to depart on a run out of Penn Station. The conductor and the engine crew always compared their pocket watches in order to strictly adhere to the railroad's demand for on-time performance. (Courtesy of Peter Lerro.)

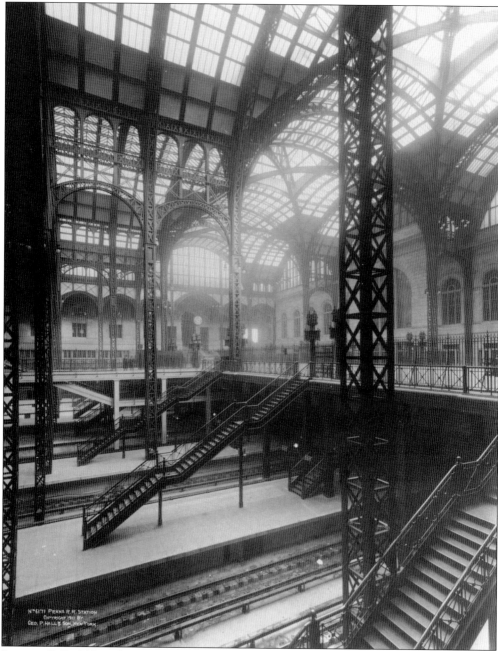

Lorraine B. Diehl best described this photograph in her book *The Late, Great Pennsylvania Station*: "Unlike the waiting room, where all was classical restraint and severity, the concourse, with its bare structural steel, suggested the motion and power of the modern age. [Architect] McKim patterned his roof on the iron train sheds of Europe but demanded more intricacy in its design. If the station's other rooms were Roman, this one was pure American." (Author's collection.)

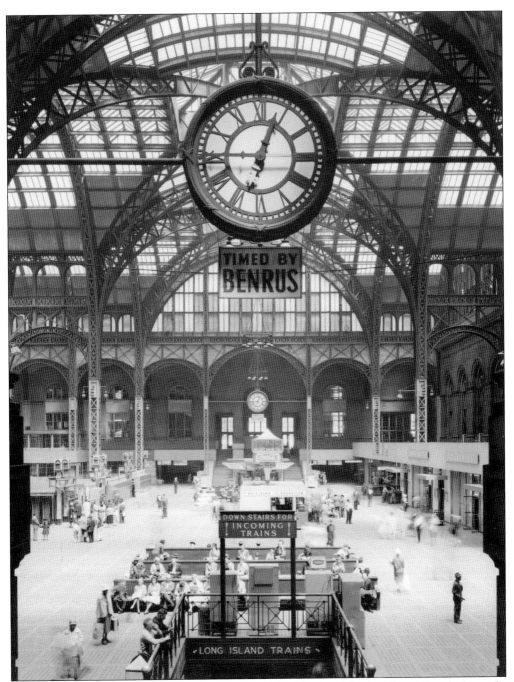

This is the concourse a few years before the 1963 demolition of the building. The clock speaks volumes, and it seems to be saying, "Time is running out." There were hundreds of clocks throughout the station, but this was the clock that governed the movement of trains by timetable authority. In the glory days of railroad passenger travel, if the *Broadway Limited* pulled into Penn Station two minutes late, the conductor and engineer would be in the superintendent's office explaining the delay. On-time performance was demanded, and management settled for nothing less. (Author's collection.)

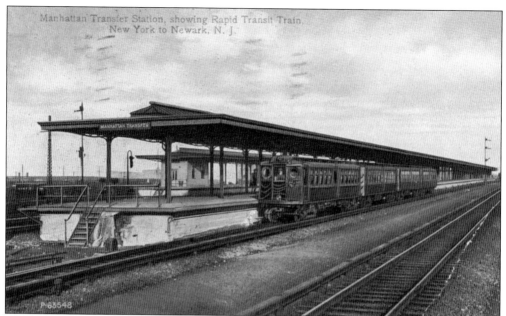

Because steam locomotives could not enter Penn Station, the PRR selected a location nine miles west in Harrison, New Jersey, for a motive power transfer. This station, known as Manhattan Transfer, was where steam locomotives were uncoupled and electric locomotives were coupled for the run into Penn Station. In this early 1900s postcard view, a Hudson & Manhattan Railroad electric multiple-unit train is seen at Manhattan Transfer. (Author's collection.)

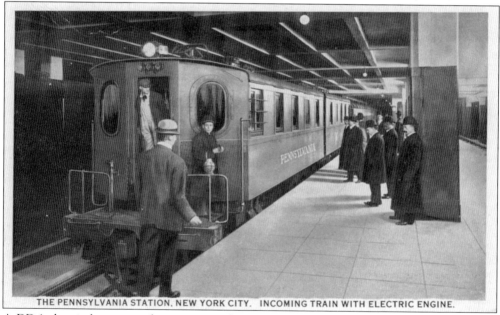

THE PENNSYLVANIA STATION, NEW YORK CITY. INCOMING TRAIN WITH ELECTRIC ENGINE.

A DD-1 electric locomotive has just arrived at Penn Station from Manhattan Transfer. These locomotives operated in pairs using 650-volt direct current (DC) provided by third rails. They were capable of traveling 85 miles per hour, but the PRR never allowed them to do more than 65 miles per hour. These locomotives were replaced in the mid-1930s by GG-1 locomotives that operated by use of overhead wires. (Courtesy of John Turkeli.)

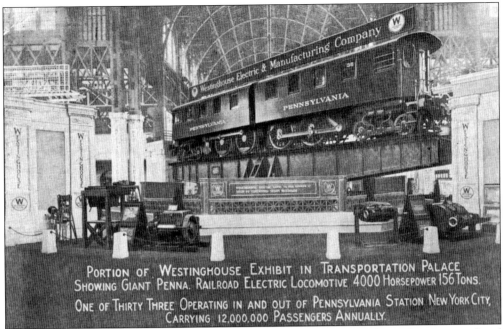

PORTION OF WESTINGHOUSE EXHIBIT IN TRANSPORTATION PALACE SHOWING GIANT PENNA. RAILROAD ELECTRIC LOCOMOTIVE 4000 HORSEPOWER 156 TONS. ONE OF THIRTY THREE OPERATING IN AND OUT OF PENNSYLVANIA STATION NEW YORK CITY, CARRYING 12,000,000 PASSENGERS ANNUALLY.

At the 1915 Panama-Pacific Exposition in San Francisco, PRR and Westinghouse Corporation placed a pair of PRR DD-1 electric locomotives on display. The locomotives were mounted on a rotating turntable that made a complete revolution every three minutes. (Courtesy of John Turkeli.)

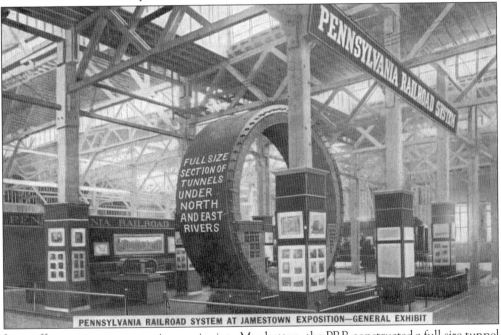

PENNSYLVANIA RAILROAD SYSTEM AT JAMESTOWN EXPOSITION—GENERAL EXHIBIT

In an effort to promote upcoming service into Manhattan, the PRR constructed a full-size tunnel cutout that was placed on display at the 1907 Jamestown Exposition. The tunnels between Manhattan and New Jersey were known as the North River Tunnels. In 1909, the name of the river was changed to the Hudson in conjunction with the Hudson-Fulton Celebration of that year. (Courtesy of John Turkeli.)

HACKENSACK PORTAL - P.R.R. TUNNEL INTO NEW YORK.

The two tunnels under the Hudson River ran parallel to each other, emerging on the New Jersey side at Bergen Hill. Sparing no expense, the Pennsylvania Railroad built an elaborate dual portal, even though it was in an area that would be rarely seen. These photographs show the portals with the ventilating shaft structure overhead. The granite was from a quarry in Millstone Point, Connecticut. Bergen Hill was at the southern end of the Hudson River Palisades. (Above, courtesy of John Turkeli; below, author's collection.)

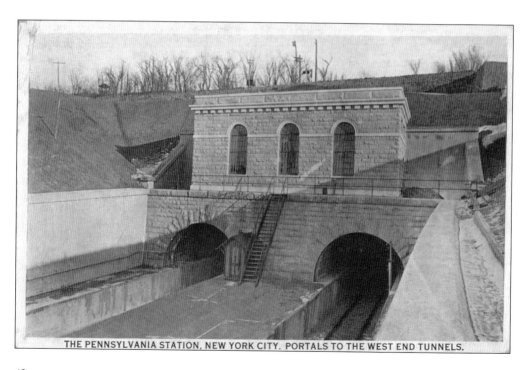

THE PENNSYLVANIA STATION, NEW YORK CITY. PORTALS TO THE WEST END TUNNELS.

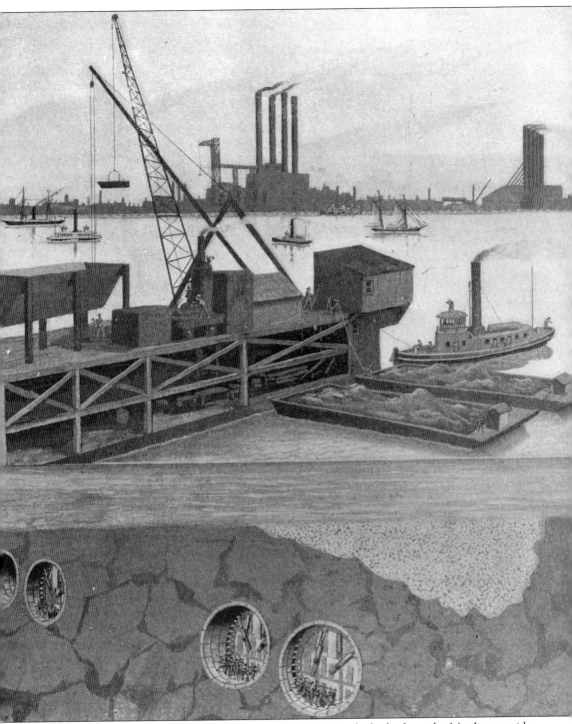

This sketch, showing a cross section of the East River Tunnels, looks from the Manhattan side toward the east. The smokestacks of the Long Island City Powerhouse are in the background. Four tunnels were under the East River, two to serve the Long Island Rail Road and two for the Pennsylvania Railroad. (Author's collection.)

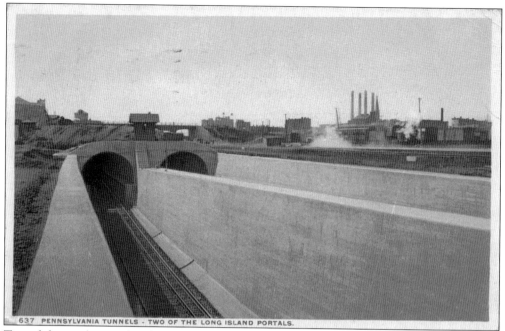

637 PENNSYLVANIA TUNNELS - TWO OF THE LONG ISLAND PORTALS.

Two of the newly completed East River Tunnels are seen in this 1910 view looking west. The chief engineer of the tunneling project was Charles Jacobs. The project started in 1904 and was completed in 1909. In the right background, the smokestacks of the Long Island City Powerhouse can be seen. Sunnyside Yard is less than a mile from the tunnel portals. (Author's collection.)

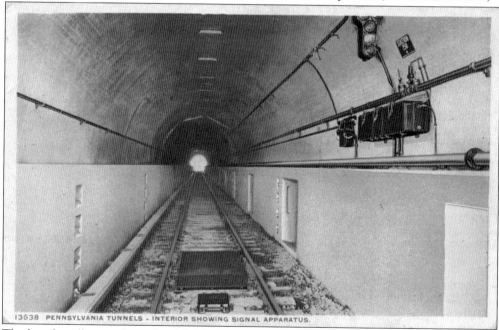

13638 PENNSYLVANIA TUNNELS - INTERIOR SHOWING SIGNAL APPARATUS.

The bench walls on either side of the tunnel were designed to keep the train in the middle of the track in case of a derailment. The walls also provided a walkway for employees, and the cable runways were inside the walls. Note the signal appurtenances at right. The light at the far end of the tunnel is known to railroad operating employees as "the mushroom." (Author's collection.)

Three

LONG ISLAND CITY POWERHOUSE

Four lofty smokestacks constitute a striking feature, viewed from miles away.

—*Scientific American* magazine

The Pennsylvania Railroad's New York Extension was a project that required an enormous amount of electricity. Steam-powered locomotive trains were not allowed to operate in the tunnels or on subsurface Penn Station tracks. Therefore, electric locomotives would have to be the motive power source.

The plan was to bring PRR trains to Harrison, New Jersey, by steam locomotives and then transfer to electric locomotives. That location became known as Manhattan Transfer. On the Long Island side, tracks of the Long Island Rail Road were electrified on the west end of the system, especially east to Jamaica. Thus, LIRR electric-powered trains could operate from Penn Station to Jamaica, and at that point, steam locomotives would take over. This is when the phrase "change at Jamaica" originally developed.

The first unit of the Pennsylvania Railroad's New York Extension was the Long Island City Powerhouse. This huge powerhouse was located between Third and Fourth Streets on the East River in Long Island City. It was necessary to drive 9,115 piles for the foundation. The concrete base over the piles was six feet, six inches thick.

Four massive smokestacks were on the four corners of the building. These smokestacks were 275 feet high with an internal diameter of 17 feet.

Coal was the fuel source for the powerhouse. Barges brought coal to the base of the coaling tower. Hoisting apparatus brought clam-shell buckets from the barge to the top of the tower where the coal was dumped into hopper cars. These cars moved on tracks into the upper level of the boiler house. There, the coal was dumped into storage bins, which fed the coal down to the powerhouse floor level.

Automatic stokers fed coal into massive boilers, which produced steam to power the 11,000-volt alternating current (AC) generators. The power was delivered to substations where it was stepped down to 625 volts and rectified to DC by the use of rotary convertors.

Construction began in the fall of 1903 and was completed in time for the start of running Long Island Rail Road electric trains on July 26, 1905.

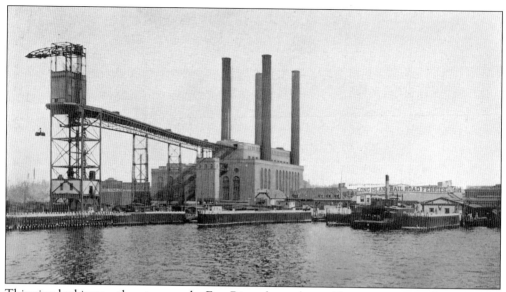

This view looking northeast across the East River shows the coal-hoisting tower and its conveyor system that carried coal from riverside barges into the powerhouse. The tower reached a height of 170 feet and dominated the East River shoreline in this area. Massive coal-fired boilers created steam that was piped into the generator room where three steam-powered turbines produced 16,000 kilowatts of electricity.

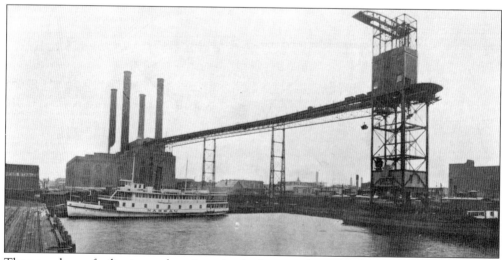

The powerhouse facility is seen here in a view looking southeast. At dockside is the Long Island Rail Road steamboat *Nassau*. Steamboat service was started by the Montauk Steam Boat Company in the mid-1880s, with the boats providing service from Long Island City to various shore points on Long Island and in Connecticut. Prior to the opening of Penn Station, railroad steamboats were at their zenith. The LIRR purchased the operation on May 13, 1899, and ran the boats until service finally ended in 1927.

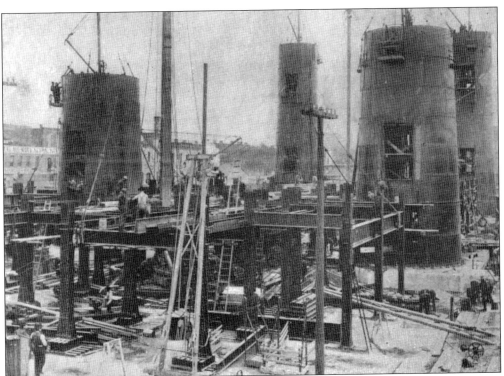

This photograph shows the four smokestacks under construction. These 275-foot-high smokestacks were made of steel and were entirely self-supporting to allow for swaying under high wind conditions. The insides of the smokestacks were lined with brick, the diameter being 17 feet at the base. The concrete base below each stack was eight feet thick. The smokestacks were demolished when the building was renovated in the early 2000s.

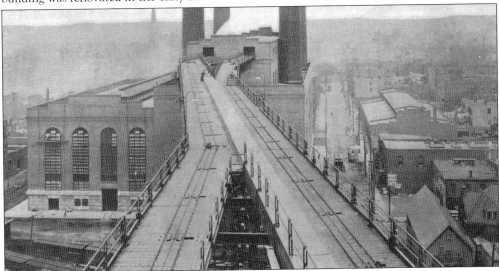

Cable-operated hopper cars ran from the coal-hoisting tower to the coal bins on the upper portion of the powerhouse. This view shows the two railcar tracks headed toward the powerhouse. Once inside the plant, coal was dumped into huge storage pockets for eventual use in the boilers. Amazingly, the coal transfer system was a one-person operation.

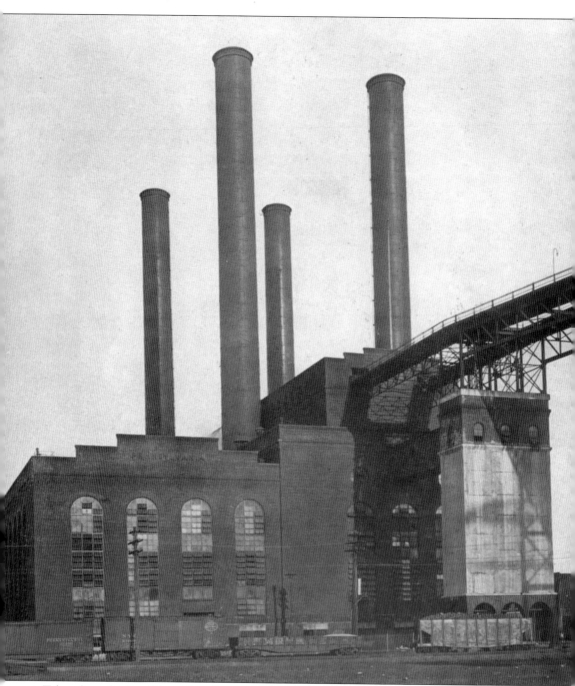

Taken from the East River, this photograph shows the west elevation of the powerhouse and its imposing brick structure, which was built on a six-foot layer of concrete, supported by over 9,000 piles. To the right are the overhead trolley tracks for bringing coal into the plant. Freight cars can be seen on the siding in front of the building. Ashes from the furnaces were hauled away by railroad hopper cars.

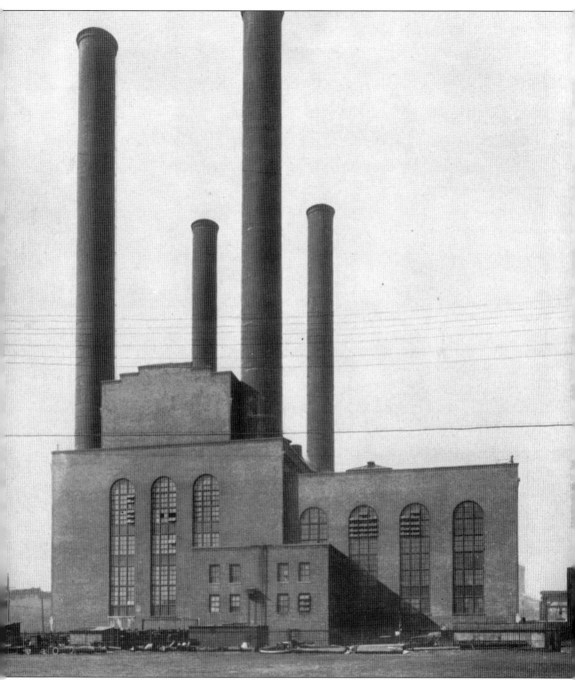

The east elevation of the powerhouse is seen here. The building was designed by McKim, Mead & White, the same architects who designed Penn Station. Located on the shore of the East River, the building was on a rectangular block extending 200 feet north and south on Front Street and West Avenue and extending 500 feet in depth along Third and Fourth Streets.

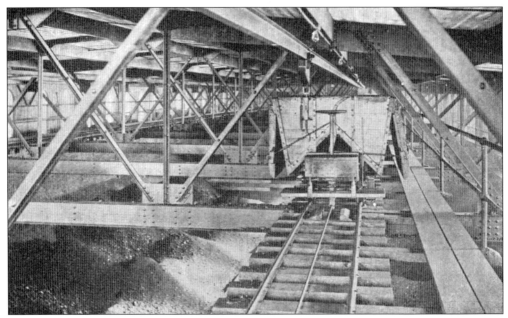

The coal-hoisting tower was designed to be a one-man operation, with control of the whole system concentrated on a single floor only a short distance above the coal barges. The coal was hoisted by a two-ton clamshell bucket attached to the boom. The distance from the coal-hoisting tower to the powerhouse was a little over 500 feet. Cable-operated hopper cars ran on railroad tracks carrying coal from the tower to the building, where the coal was dumped into hoppers.

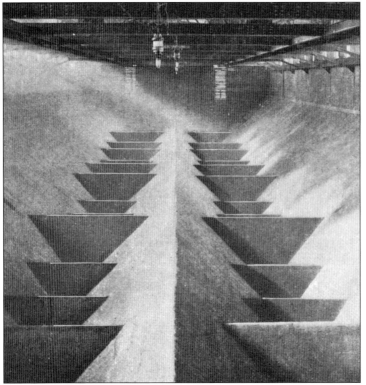

Once inside the upper level of the powerhouse, the cable hopper cars operated on a continuous loop, dumping coal into huge storage bins, seen here, and returning dockside to receive more coal. The cable railway was able to handle 150 tons of coal per hour using 29 two-ton cars operating at a speed of 180 feet per minute around a 2,500-foot loop.

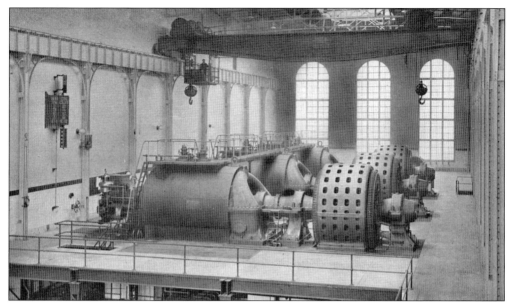

The turbine room housed three Westinghouse-Parsons steam turbines, which powered electrical generators producing 11,000 volts of AC electricity. The first of these units was placed into operation on April 15, 1905. Electricity from here was sent to remote substations where rotary converters reduced the current to 660-volt DC for the operation of trains.

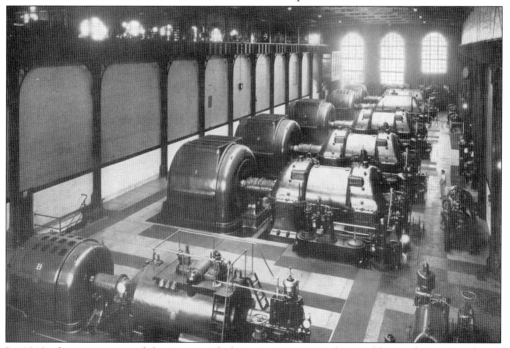

In 1910, there was a need for increased electric service, so three additional steam turbines were installed, as seen here. The powerhouse supplied electricity for the Penn Station traction operation, signal operation, and electric third-rail power on the Long Island Rail Road and the PRR third rail out to Harrison, New Jersey. There was also a rotary converter substation on one end of the powerhouse.

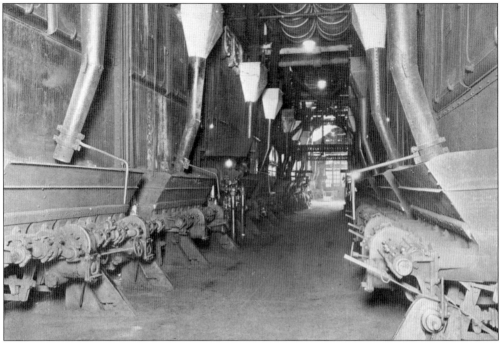

The boiler room was 103 feet wide between the walls and contained 32 Babcock & Wilcox horizontal tube boilers. These boilers provided the super-heated steam that powered the steam turbines. Exhaust gases from these boilers were vented through the four smokestacks.

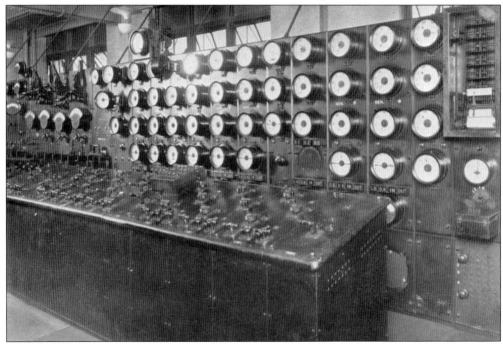

The complexity of the operation of the powerhouse is best illustrated by the main generator switchboard, which was located inside the electrical bay, a room 25 feet wide that contained all of the necessary switching and auxiliary equipment for the distribution of electric power.

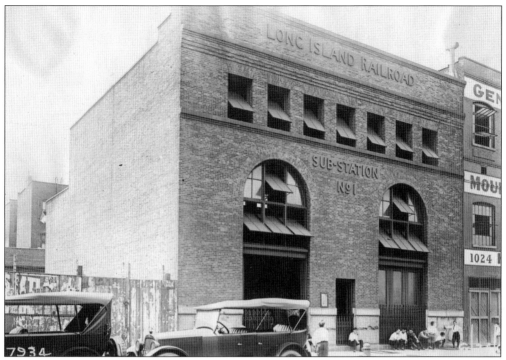

The extent of the Long Island City Powerhouse function cannot be fully appreciated without looking at the operation as it extended to outlying points. For this purpose, the electric service provided to the LIRR will be examined. Five electric substations were built on Long Island. Substation No. 1, pictured here, was on Grand Street in Brooklyn. It was smaller in size than the others, due to property line constraints in this congested area.

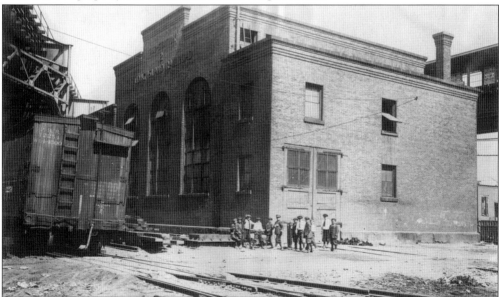

Substation No. 2 was on the southeast corner of the Atlantic and Manhattan Beach Divisions. This March 28, 1921, valuation photograph is rather unusual in that it shows a group of children in front of the building. Most valuation photographs were devoid of people.

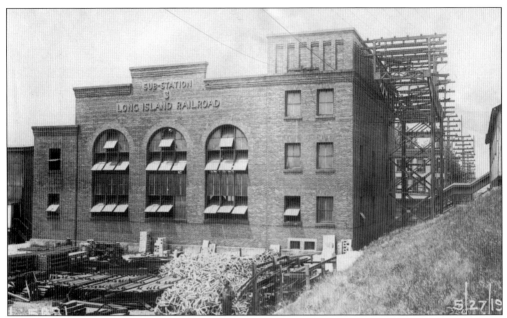

These two photographs show Substation No. 3 at Woodhaven Junction, which was the junction of the Atlantic Branch and the Rockaway Beach Branch. The substation was located on Atlantic Avenue between Ninety-eighth and 100th Streets. The steel structures affixed to the building are cable racks. These racks, or terminal poles, provided a means by which the high-tension cables could be kept separated and fed into the appropriate pigeon holes on the side of the substation.

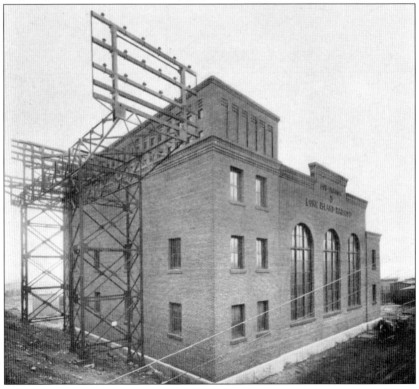

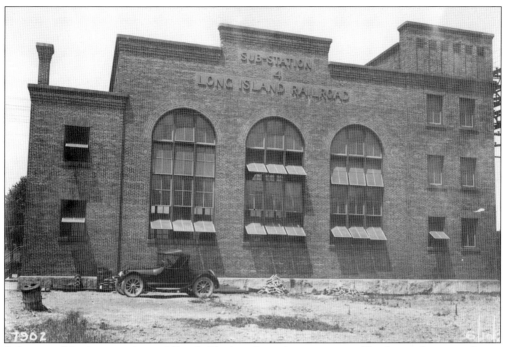

Substation No. 4 was in the middle of a block, a short distance west of Rockaway Junction. It was located in such a way that the building could be extended toward the rear of the lot if expansion became necessary. There was also room for a storage battery house at this location.

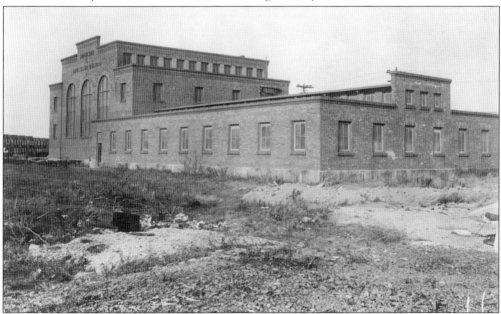

Substation No. 5 at Hammels was quite unique. Feeder cables were underground at this substation because it was too close to the Beach Channel drawbridge to make it worthwhile to change from underground to overhead transmission. Also, attached to the substation was a building measuring 100 feet by 63 feet. This building housed a large quantity of batteries, which would supply power to operate the drawbridge in case of power outages from the Long Island City Powerhouse.

In addition to the five fixed substations, the LIRR had two portable substations. These were railroad cars that contained 1,000-kilowatt rotary converters, transformers, circuit breakers, and control panels. These portable substations were made necessary by the extremely heavy but very infrequent loads incidental to the service of the Belmont and Jamaica racetracks. The storage building for the cars was 88 feet by 17 feet with a tower at the far end for high-tension cables and lightning arresters.

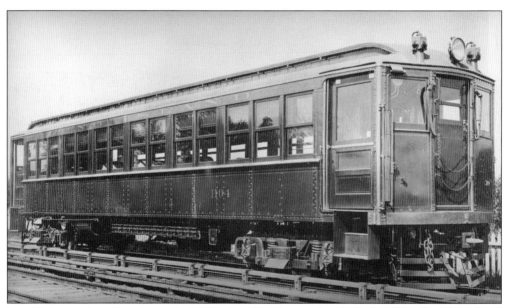

In addition to the substations, the LIRR electrification project included 88 miles of third rail to supply current to the collection shoes of the railroad cars. The railroad purchased 135 new, all-steel multiple-unit cars. These cars, classified as MP-41, were manufactured by American Car & Foundry in 1905.

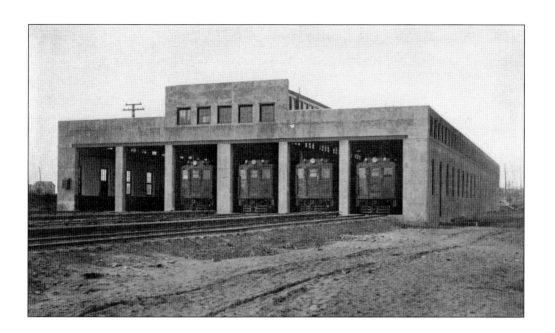

The Dunton Electric Car Shop, a new facility, was opened in 1905 to provide for inspection and light maintenance of the electric car fleet. The building was located between Jamaica Station and the Morris Park Shops. Originally six bays, it was expanded in later years and has since been demolished. Actual repair work was done at Morris Park, which had the necessary machinery and tools for performing heavy repair work.

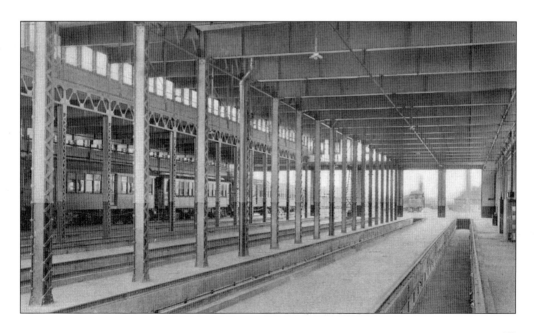

This 1937 photograph shows an LIRR DD-1 electric locomotive at the Long Island City Station. After the PRR acquired GG-1 locomotives in the mid-1930s, excess DD-1 locomotives were given to the LIRR to perform service between Penn Station and Jamaica Station. In the background is the railroad's YMCA building, and beyond that are the four smokestacks of the powerhouse.

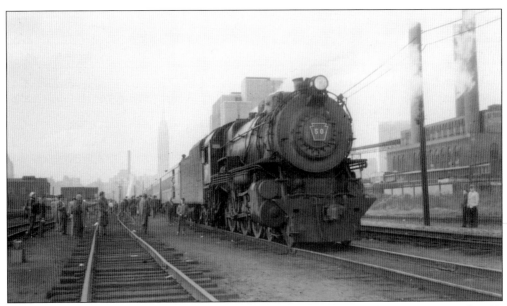

The Branford Electric Railroaders Association conducted a fan trip on the LIRR on October 31, 1954. Over 400 railfans enjoyed a day touring the LIRR on trains hauled by steam locomotives. On a photo op at Long Island City, steam Locomotive No. 50 can be seen at the head end of the train. The Long Island City Powerhouse is at right. The building looming over the locomotive in the background is the ventilator shaft for the Queens-Midtown Tunnel. (Courtesy of John Turkeli.)

Four

CONSTRUCTING THE TUNNELS AND THE YARD

Sunnyside Yard, for sheer magnitude was the largest entity of the New York Extension and the largest coach yard in the world.

—Carl W. Condit

The Pennsylvania Railroad decided to construct the passenger car storage yard in an area east of Penn Station, known locally as Sunnyside. As legend has it, the name originated with the Bragraw family of French Huguenots who purchased the land in 1713 and named their estate Sunnyside Hill.

Once the decision had been made as to the location of the yard, the next task was to purchase the large amount of land necessary to build it. Plans called for the yard to extend from Thompson Avenue to Woodside Avenue, nearly two miles long and 1,635 feet wide. That would require the acquisition of more than 200 acres.

A portion of the sought-after land was 40 acres of swamp. The remaining land was rolling ground varying from 10 to 70 feet above the swamp. On this high ground, 246 buildings had to be removed and 52 streets had to be eliminated.

Land purchases began in 1902 by various real estate companies. The purpose for buying the land was kept secret as long as possible in order to prevent land values from becoming inflated.

Excavation began in December 1906 using 4 steam shovels, 11 narrow-gauge locomotives, and 150 dump cars. Notwithstanding the great amount of filling over the swamp and low ground, there was an excess of excavated material. Part of the excess was used by the Long Island Rail Road in new construction work at nearby points and part by the Degnon Realty and Terminal Improvement Company in filling some of the swampy part of its property. The Degnon property would become an industrial development south of Sunnyside Yard.

Excavation work was completed in late 1909. An extensive amount of work was performed constructing sewers, water and steam pipelines, and electrical conduits. Laying of track was completed about one year later. The yard officially opened on November 27, 1910, at a cost of $7 million. In today's dollars, this would be over $170 million.

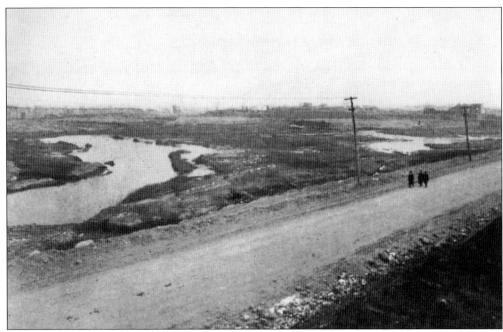

A swamp of 40 acres extending from Honeywell Street and Jackson Avenue to Thompson Avenue presented a major problem. The main advantage of making use of this swampland was that the land was cheap—dirt cheap. A blanket of earth over four feet thick was necessary to fill in the swamp.

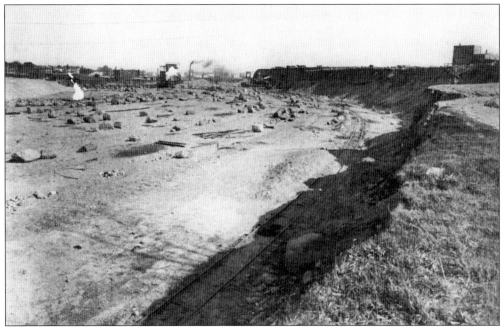

The excavation consisted of sand, gravel, and rocks, as well as trap boulders. The boulders, while numerous and somewhat troubling in places, formed a smaller portion of the excavation than had been originally anticipated. Nearly all of the boulders were broken up and used in the concrete masonry.

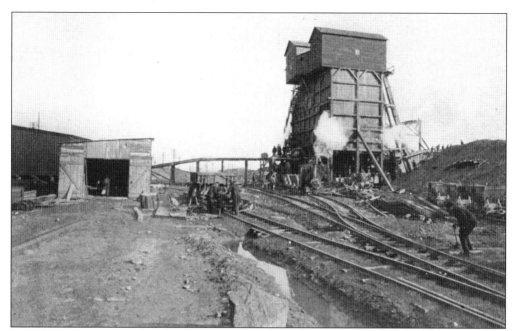

As with most major construction projects, concrete was mixed on-site, eliminating high transportation costs. The photograph above shows the crusher, which broke up boulders to be used in the concrete mix. Below is the concrete mixing plant. The sand, which was abundant throughout the excavation site, was tested and found to be best for mixing concrete. It gave a stronger mortar than the Hempstead Harbor sand (the New York City standard sand). Thus, much of the excavated material was made useful in the construction of the tunnels, bridges, and sewers.

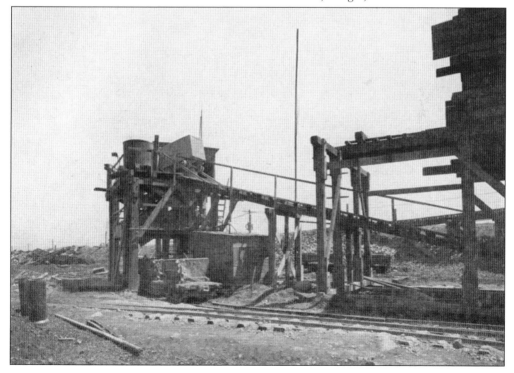

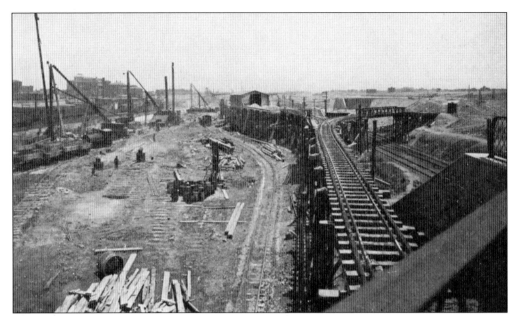

Here, tracks are seen being constructed. Over 10 miles of track was necessary to move flatcars, hopper cars, and dump cars that were used in performing excavation and construction work. The magnitude of the work was compared to that of the Panama Canal. Both projects required moving lots of earth, rocks, and material by rail.

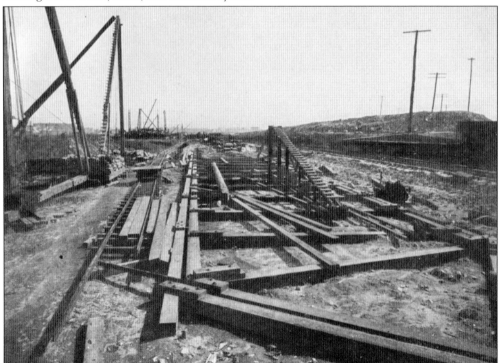

This view of the south abutment of the Hunters Point Avenue Bridge shows the framing of the top set of timbers. To the left, the cranes of the day can be seen. They were basically wood beams and pulleys.

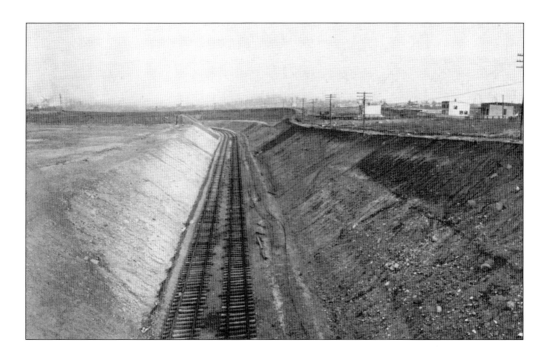

The ingenious aspect of Sunnyside Yard were the loop tracks. These tracks, located at the east end of the yard, allowed trains to enter the yard tracks from the east end and exit the same track from the west end en route back to Penn Station. Thus, there were no conflicting movements that would have been present in a yard having its entrance and exit at the same end. These two views show the loop tracks under construction.

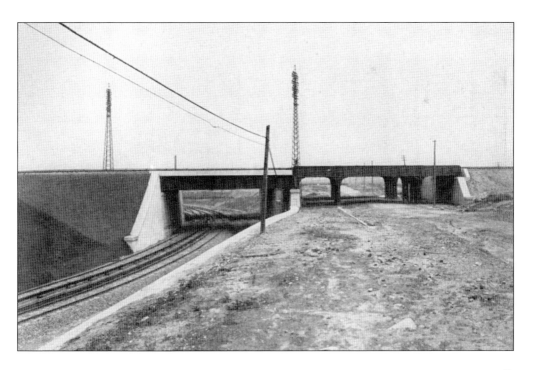

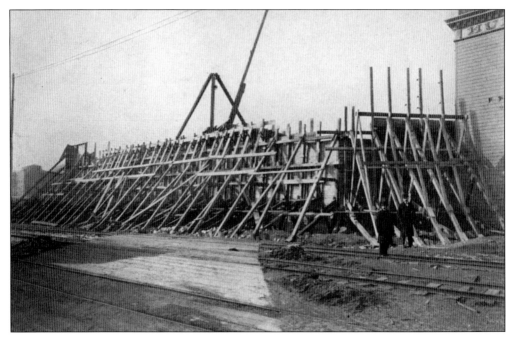

The Thompson Avenue Viaduct passed over the western part of Sunnyside Yard. As with all of the other highway bridges that crossed the yard, this was a deck-type plate girder bridge with masonry abutments on each end. Since the girders were of an insufficient depth to carry the city water pipes below the deck, a width of three feet, six inches was added on both sides of the bridge, outside of the hand rails, to accommodate them. The photograph above shows the masonry form work for the north abutment; below is the completed masonry.

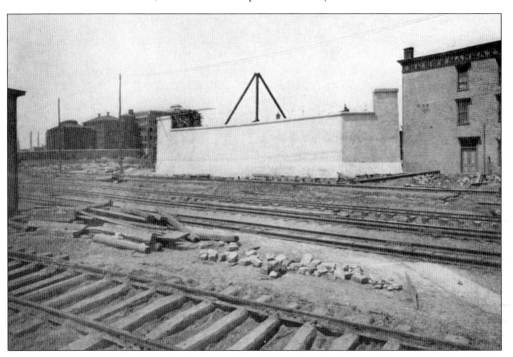

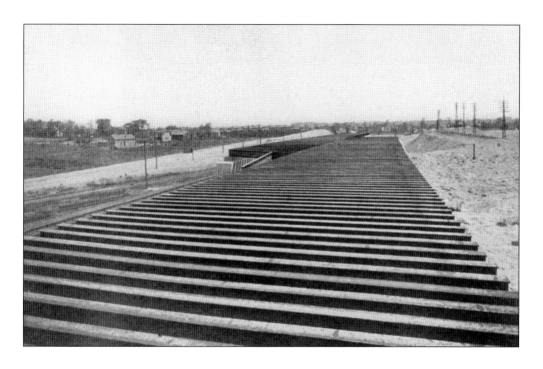

No expense was spared in constructing the bridges that crossed over the yard. These two photographs show the amount of work that was put into construction of the bridge decks. The above photograph shows the crossbeams before placing the concrete floor. The below photograph shows floor-reinforcing steel bars that were placed prior to the concrete being poured. Waterproofing material was placed between the layers of concrete.

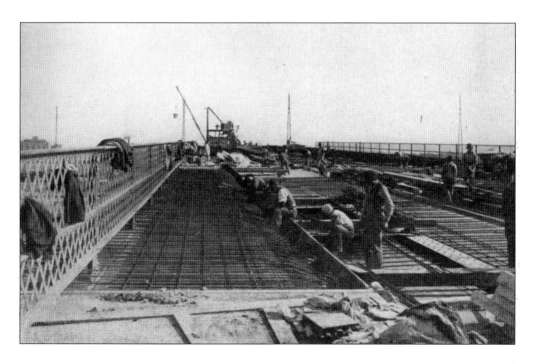

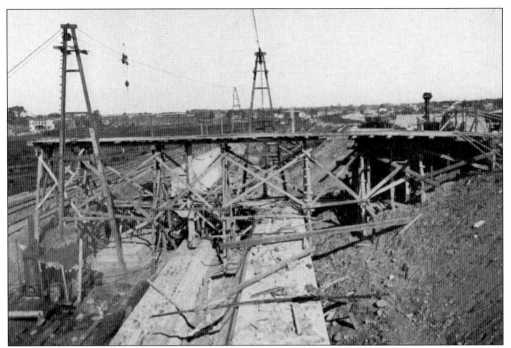

The intricate nature of the wooden support structures necessary during the construction work is illustrated in this photograph. The cranes were primitive upright beams with ropes and pulleys. Yet the quality of the construction work is proven by the years that these structures have been in existence.

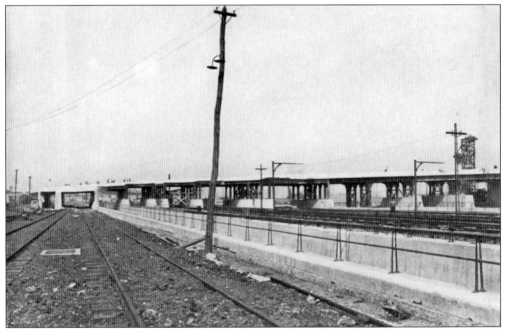

This photograph is identified on the reverse as "overhead double-track freight bridge." This is the bridge that carries tracks from the LIRR North Yard (Yard A) across the western portion of the yard to the old Montauk Branch. This line is now known as the Montauk Cutoff.

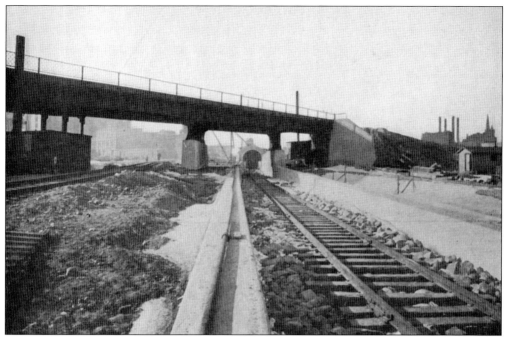

The Hunters Point Avenue Bridge is west of the Hunters Point Avenue Station. The Long Island City Powerhouse can be seen in the distance at right.

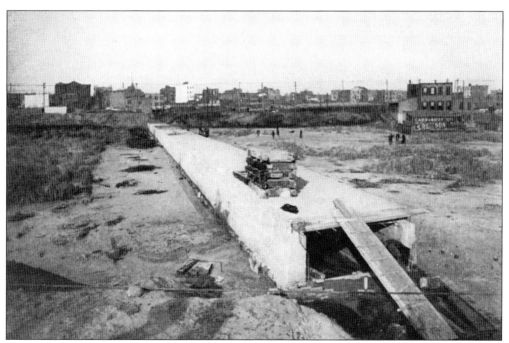

A major part of the Sunnyside Yard construction work involved the construction of sewers. The slope and shape of the yard caused the surface drainage to flow toward the tunnel portals, and it was necessary to intercept it by an adequate sewerage system. This photograph shows the largest section of sewer, measuring nine feet by six feet resting upon piles before being covered.

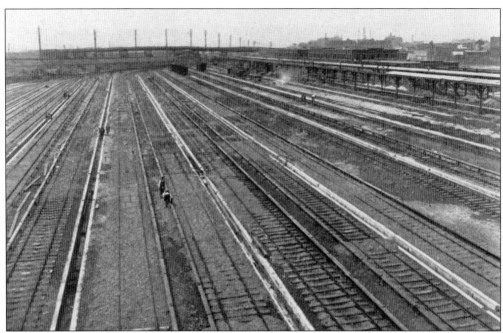

Based on the great number of water, steam, gas, and air pipes throughout the yard, it was decided to place them in concrete trenches so that they could be reached without difficulty for alteration or repair. Both sides of the trenches contained conduits for carrying wires. This photograph shows the trenches before the four-inch-thick plank coverings were put into place.

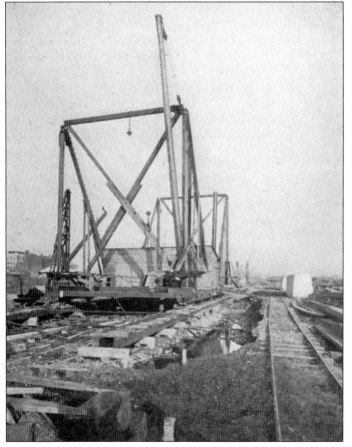

In sharp contrast to the tower cranes that are seen at construction sites today, this traveling derrick made of wood framing, ropes, and pulleys provided the heavy lifting functions. This piece of equipment could be moved on rails as construction work progressed.

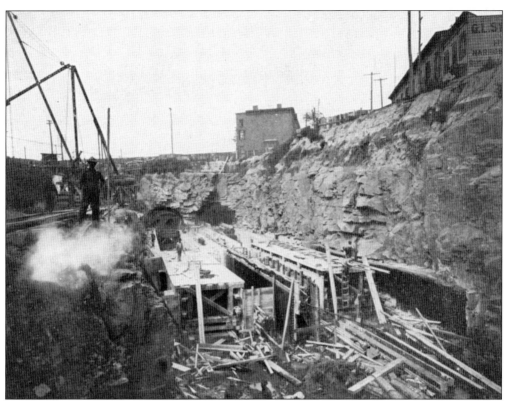

Tunnels A and B were constructed in rock and were in close proximity to each other, as seen in these photographs. These portals were located east of Hunters Point Avenue Station, just west of the Montauk Cutoff Viaduct. Many water springs were encountered in the rock excavations and great care was required to handle the water so as to prevent it from washing the cement out of the concrete floors and leaving them porous. Waterproofing work was an important aspect of tunnel construction.

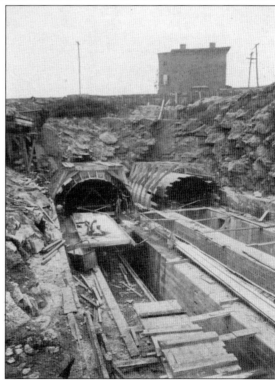

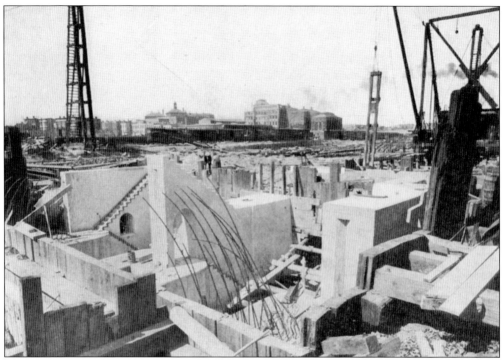

These two views illustrate the massive amount of concrete work that was necessary in the tunnel construction work at the east end of the tunnels. The reinforcing bars (rebar) can be seen sticking up from the concrete forms. The primitive machinery of this era is also evident in these photographs.

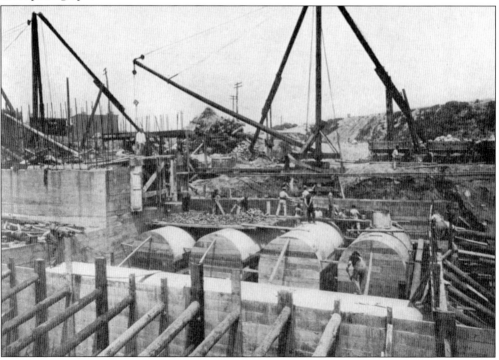

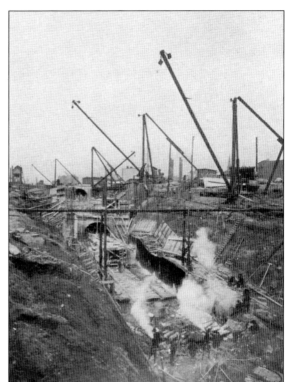

Tunnel C crossed over Tunnel B, as can be seen in these two photographs. Concrete work at the tunnel portals was done in four operations, which included floor work and all work below the duct benches, side walls, and tunnel arch.

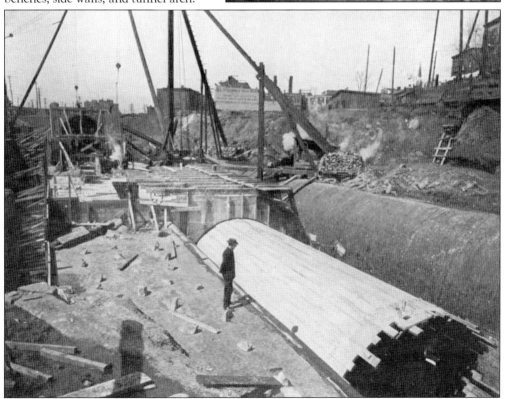

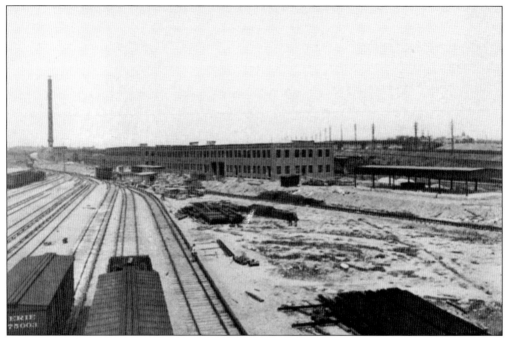

At far left is the smokestack for the boiler house, and moving toward the center, the commissary and store building can be seen under construction. In 1909, the Pennsylvania Railroad moved its commissary operation from Jersey City to Sunnyside Yard.

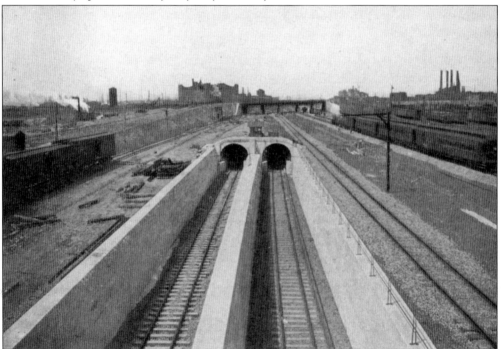

These are the portals for Tunnels B and D, looking west. In the background is the Hunters Point Avenue roadway overpass. The smokestacks for the Long Island City Powerhouse are at right in the background.

Five

SUNNYSIDE YARD
OPERATION

Today Sunnyside Yard stands hushed, witness to the past grandeur
of passenger rail travel in the United States.

—Nicholas Kalis

Sunnyside Yard certainly is not what it used to be in the glory days of the famous cross-country passenger trains. Some of those trains were all-Pullman sleeping car trains, equipped with lounge cars and dining cars. Some of the trains that made up at Sunnyside Yard and originated at Penn Station were the *Broadway Limited, Congressional, Spirit of St. Louis, Red Arrow*, and the *Pennsylvania Limited*.

The yard opened on November 27, 1910, at a cost of $7 million. The main feature of the yard was a continuous loop at the east end that allowed trains exiting Penn Station to go around the loop into yard tracks to allow them to head west for re-entry into Penn Station. There were 75 yard tracks that would accommodate over 1,100 cars. The yard was 3.5 miles east of Penn Station and 1.6 miles from the East River.

Trains arriving at Penn Station would discharge passengers and head east to Sunnyside Yard for servicing and preparation for Penn Station outbound trips. Trains going into the yard first went through a wash machine, which washed the locomotive and the exterior of all cars. Trains then went around the loop track and into a designated yard track for servicing.

Servicing involved mechanical inspection and maintenance. Dining cars were placed on the "house track," where they were thoroughly cleaned and restocked with china dinnerware, silverware, tablecloths, cloth napkins, food, liquor, and ice. Fresh cut flowers were placed on every dining car table.

The Pullman Company had its own building in Sunnyside Yard, which included one of the largest laundries in the city, as well as a training facility for porters and dining car attendants. Mock-ups of dining car kitchen interiors made training authentic.

There was an engine house on the north side of the yard where electric locomotives were inspected and light repairs were made. About 106 locomotives were serviced on a daily basis. Locomotives in need of heavy repair were moved under their own power or were towed to the Wilmington, Delaware, shop facility.

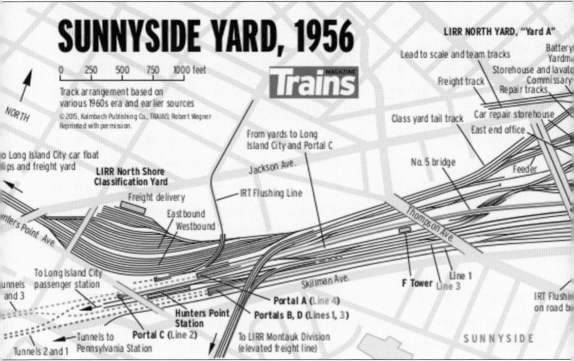

SUNNYSIDE YARD, 1956

0 250 500 750 1000 feet

Track arrangement based on
various 1960s era and earlier sources
© 2015, Kalmbach Publishing Co., TRAINS; Robert Wegner
Reprinted with permission.

Trains MAGAZINE

NORTH

LIRR NORTH YARD, "Yard A"

Lead to scale and team tracks

Battery
Yardm.

Storehouse and lavato
Commissary
Repair tracks

Freight track

Car repair storehouse

Class yard tail track

East end office

No. 5 bridge

Feeder

From yards to Long
Island City and Portal C

Jackson Ave.

o Long Island City car float
lips and freight yard

LIRR North Shore
Classification Yard

IRT Flushing Line

Freight delivery

Eastbound
Westbound

nters Point Ave.

Thompson Ave.

To Long Island City
unnels passenger station
and 3

Skillman Ave.

F Tower

Line 1
Line 3

IRT Flushi
on road b

Hunters Point
Station

Portal A (Line 4)
Portals B, D (Lines 1, 3)

SUNNYSIDE

Tunnels to
Tunnels 2 and 1 Pennsylvania Station

Portal C (Line 2)

To LIRR Montauk Division
(elevated freight line)

This 1956 diagram of Sunnyside Yard shows major features including, from left to right, LIRR
North Shore Classification Yard, Hunters Point Avenue Station, Montauk Cutoff, F Tower,
Thompson Avenue overpass, Queens Boulevard overpass, Q Tower, LIRR Yard A, Honeywell
Avenue overpass, Harold Tower, R Tower, Harold Avenue overpass (today's Thirty-ninth Street),
Railway Express building, and the Loop Tracks. (Going forward in the book, note that Thirty-
ninth Street will be used when referring to Harold Avenue.) The main yard tracks are between
Queens Boulevard and Thirty-ninth Street. The service buildings for the yard, between Queens

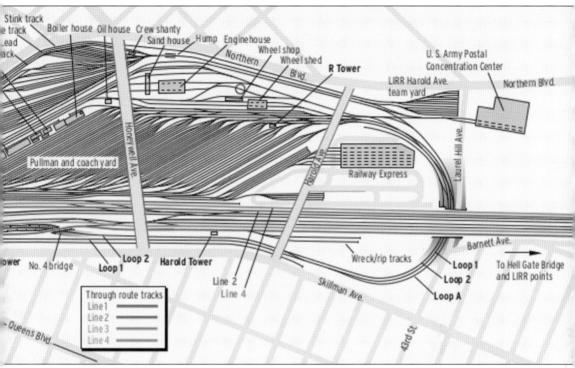

Boulevard and Honeywell Avenue, include the storehouse, commissary, battery house, first aid facility, boiler house, and oil house. The locomotive service facility, located on the north side of the yard between Honeywell Avenue and Thirty-ninth Street, include the sand house, engine house, wheel shop, and an infrequently used turntable. This area looks vastly different today, with most of the buildings and yard tracks having been removed. (With permission of Kalmbach Publishing Company, *Trains* magazine.)

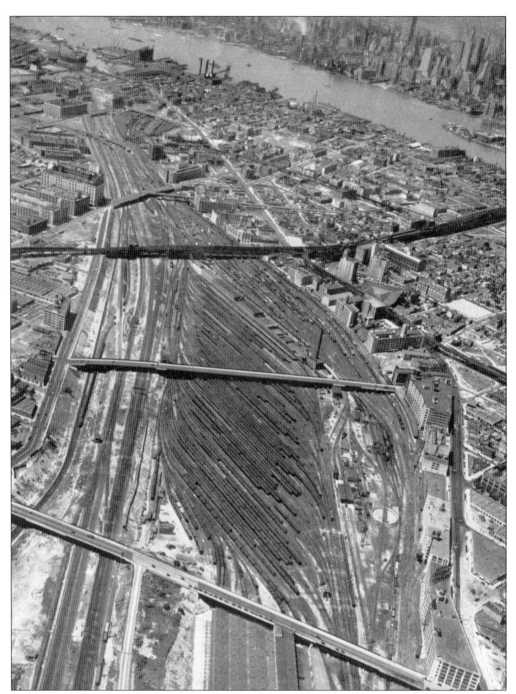

This 1939 aerial photograph shows Sunnyside Yard looking west toward the East River and Manhattan. Starting in the foreground, the bridges crossing over the yard are for Thirty-ninth Street, Honeywell Avenue, Queens Boulevard, and Thompson Avenue. At left are the Long Island Rail Road main line tracks. The Long Island City waterfront is now saturated with high-rise office buildings and residence towers. (Author's collection.)

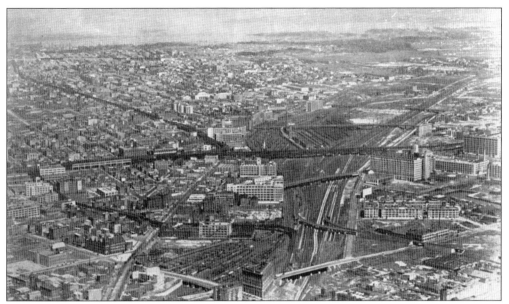

This 1926 aerial photograph, looking east, shows the enormity of Sunnyside Yard and the surrounding industrial area. The street going across the tracks in the foreground is Hunters Point Avenue. The largest building to the right is the Sunshine Biscuit Company facility. Other buildings in the area included Chicklets Chewing Gum, Swingline Staples, and Steinway Piano. The area thrived with industry due to its close proximity to the East River and Newtown Creek. The abundance of rail service was also instrumental in expansion of industry. (Author's collection.)

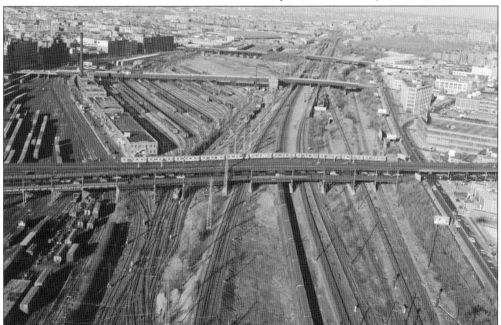

This 1977 aerial photograph looking east shows a No. 7 subway train going over the tracks on the Queens Boulevard Viaduct (in the foreground). At left is the Long Island Rail Road Yard A, to the right of which are the commissary and store building and the smokestack of the yard boiler house. The road to the far right is Stillwell Avenue. (Courtesy of the Library of Congress.)

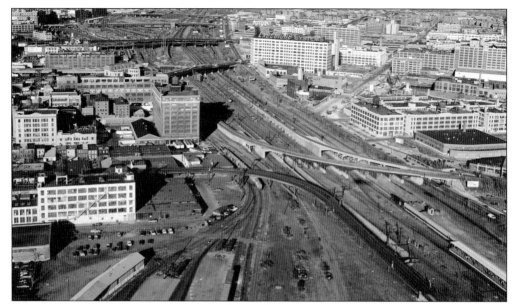

This mid-1970s aerial photograph looking east shows the LIRR Montauk Cutoff tracks crossing over the main line and going off to the right. At the lower right, an LIRR passenger train can be seen at the Hunters Point Avenue Station. The large building at center is Executone Systems (formerly the Sunshine Biscuit Company, which vacated the building in 1965). (Courtesy of the Library of Congress.)

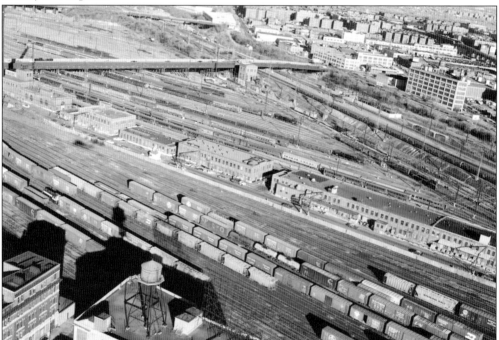

This mid-1970s aerial photograph looking southeast shows the Long Island Rail Road Yard A freight yard in the foreground. The rooftop water tank in front of the yard is one of many in the area. The row of Sunnyside Yard service buildings is at center, with the boiler house at far left. The street going across the tracks is Honeywell Avenue. (Courtesy of the Library of Congress.)

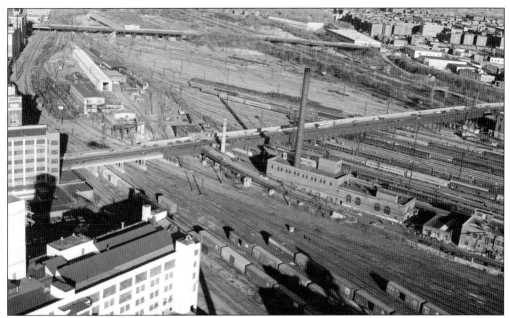

This is a great aerial view of the V, at right, and the engine house at left. Honeywell Avenue cuts across the entire yard. The boiler house provided steam heat to heat the cars that were stored in the yard, as well as power for yard lighting and charging batteries. The engine house provided light maintenance for the electric locomotives and had a nearby sanding facility. (Courtesy of the Library of Congress.)

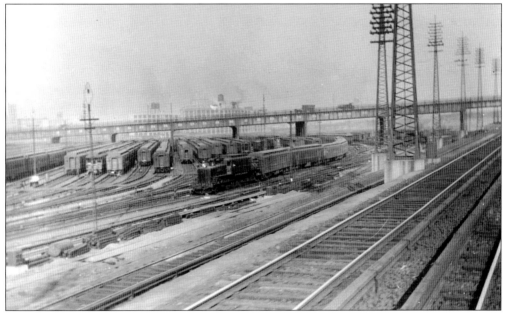

A good idea of the number of passenger trains that could be held in Sunnyside Yard can be seen in this early 1930s view at the west end of the yard. Track numbers were on the Queens Boulevard Bridge. Note the absence of overhead catenary wires. The yard was not equipped with catenary until 1932. At center, a westbound electric L-5 locomotive pulls a passenger train toward Penn Station. (Courtesy of Gene Collora.)

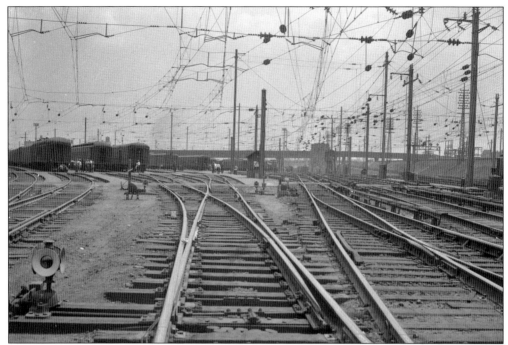

These two photographs, taken by the LIRR Claims Department photographer Fred J. Weber on June 16, 1943, show the intricacy of the 11,000-volt AC overhead catenary wires that were mounted throughout the yard. The yard opened in 1910 with third rails providing the current for the operation of the locomotives. In 1932, the PRR replaced most of the third rail with the catenary system. Some third rail was retained, as seen at right above. Below is a GG-1 locomotive (left) and a B-1 locomotive with raised pantographs. (Both, author's collection.)

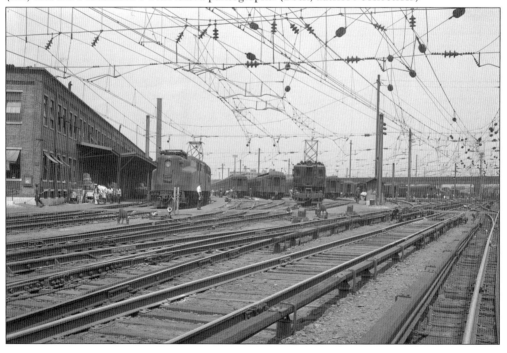

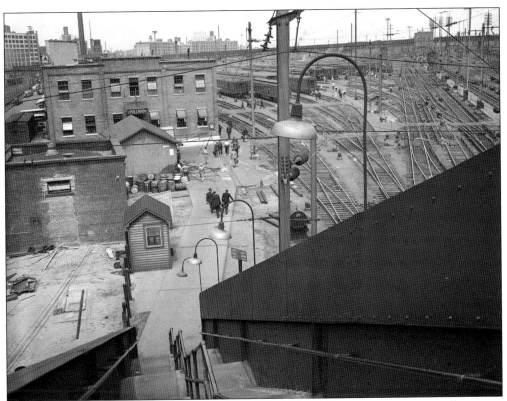

The Pullman Company had a staff of 650 full-time employees at Sunnyside Yard. The Pullman cars were thoroughly cleaned, including spraying disinfectant into the cars to remove any insects under carpeting or behind wall panels. All bedding, towels, and restroom supplies had to be restocked. The Pullman Company had an unblemished reputation for cleanliness. (Author's collection.)

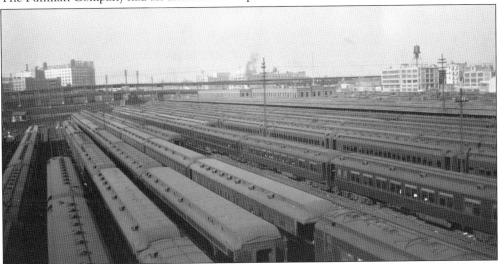

This is the Pullman car yard looking west in 1921, during the pinnacle of passenger railroad traffic in the United States. Hundreds of Pullman cars were serviced here on a daily basis. This view looks west toward Q Tower and the Queens Boulevard overpass. The commissary building is in the distance at center. (J. Osborne photograph, courtesy of David Keller).

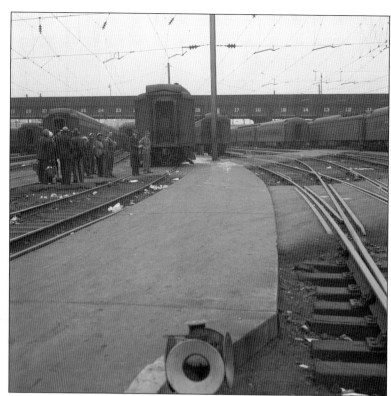

LIRR Claims Department photographer Fred J. Weber took this photograph in Sunnyside Yard on May 11, 1943. This was during World War II, when photography was strictly forbidden around railroad facilities—unless authorized, as Weber was. At bottom is a switch lamp, which had different colors to indicate the position of the switch. (Author's collection.)

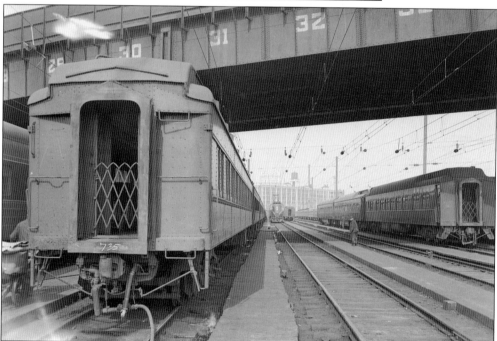

Track numbers were painted on the street overpasses throughout the yard. This April 7, 1949, view looking east shows the end gates of two Pullman coaches. A GG-1 locomotive can be seen in the distance. (Author's collection.)

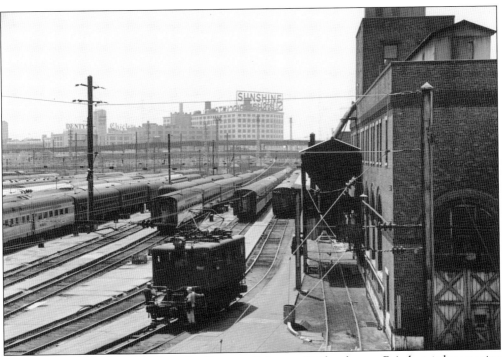

This 1960s photograph taken from the Honeywell Avenue Bridge shows a B-1 electric locomotive in the foreground and the boiler house at right. The Queens Boulevard Bridge is in the distance, and beyond that is the Sunshine Biscuit Company building. (Courtesy of Jim Mardiguian.)

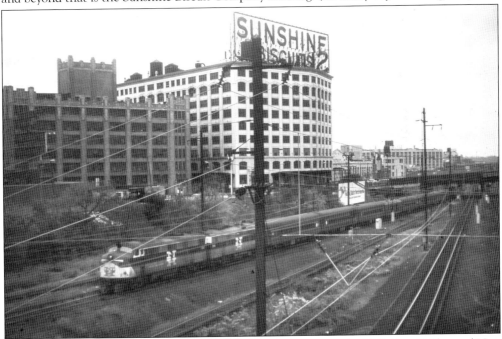

A New Haven Railroad eastbound passenger train is en route to the Hell Gate Bridge and New England on October 8, 1967. The Sunshine Biscuit Company building is in the background, and at right is the Thompson Avenue overpass. (Author's collection.)

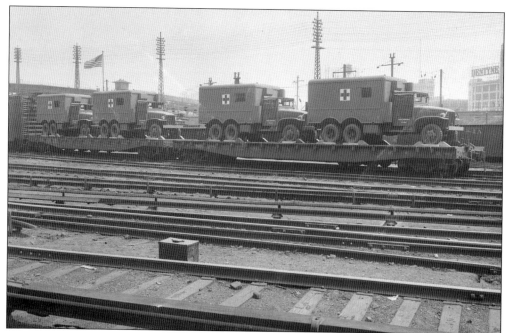

A shipment of brand-new Red Cross ambulances was photographed by LIRR Claims Department photographer Fred J. Weber on July 25, 1943. A photograph such as this leaves one to ponder the fate of these vehicles. In the far background is the No. 7 subway train. (Author's collection.)

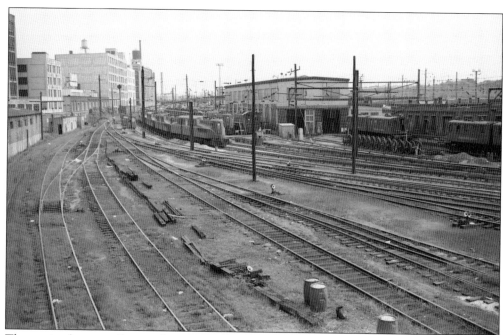

The engine house at Sunnyside was capable of servicing 106 electric locomotives in a day. In this September 5, 1960, photograph, GG-1 locomotives are to the left of the engine house, and DD-1 locomotives are to the right. The sanding tower is just out of view at right. (Courtesy of David Keller.)

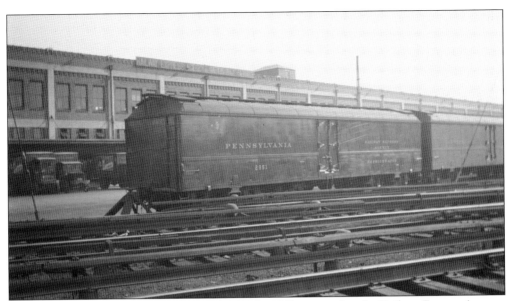

Pennsylvania Railroad refrigerator (reefer) Car No. 2961, assigned to the Railway Express Agency, is outside the REA building, which was located between Thirty-ninth Street and the loop track in May 1937. The sign on the building reads, "Railway Express Agency Nationwide Service." Note the third rails present in this area. (Courtesy of David Keller.)

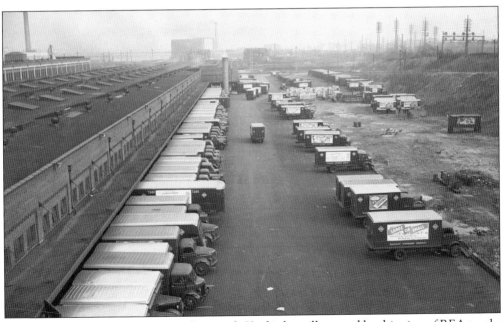

The scope of the REA operation at Sunnyside Yard is best illustrated by this view of REA trucks on December 8, 1946. Formed in 1929, the REA handled parcels until it went out of business in 1975. Enter United Parcel Service and Federal Express. (Courtesy of David Keller.)

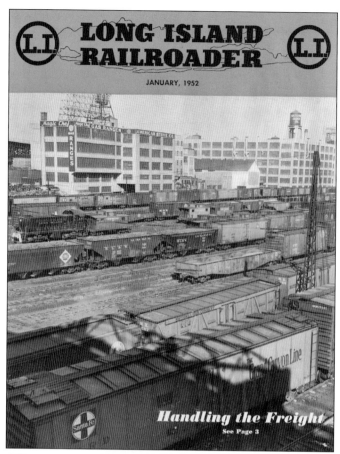

On the north side of the Sunnyside Yard complex, the Long Island Rail Road had a freight yard designated "Yard A." The operation of the yard was highlighted in the January 1952 LIRR employee news magazine *Long Island Railroader*. In the background of this cover photograph, the buildings of the American Stove Company (left) and the American Casket Company can be seen. (Author's collection.)

Amtrak AEM-7 electric Locomotive No. 906 is seen outside the commissary in May 1989. With its big Sunnyside Yard sign below the roofline, this building has been demolished. In the background, a towering building can be seen; today, buildings such as this are in abundance throughout the area. (Author's collection.)

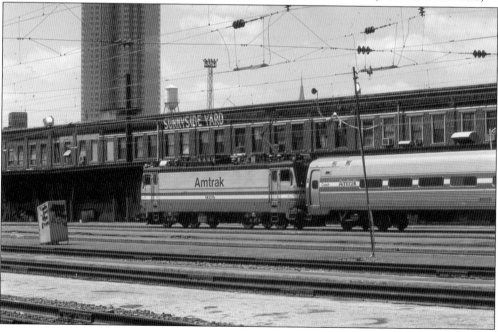

Six

THE REMARKABLE GG-1 LOCOMOTIVE

Brute force can have a very sophisticated appearance, almost of great finesse, and at the same time be a monster of power.

—Raymond Loewy

This chapter deals exclusively with the Pennsylvania Railroad's GG-1 locomotive, which was the workhorse for the railroad's long-distance passenger trains beginning in 1934. These great locomotives ran for nearly 50 years before retiring from service. For anyone who can remember trains in Sunnyside Yard prior to 1980, these were the most prevalent locomotives in the yard.

A total of 139 GG-1 locomotives were built jointly by General Electric, Baldwin, Westinghouse, and the Pennsylvania Railroad Altoona Shops between 1934 and 1943. They received their electric power from 11,000-volt AC overhead wires. The streamlined operating cab was in the center, and a pantograph was on each end of the locomotive roof. Designed for bidirectional operation, they were capable of hauling trains at 100 miles per hour.

The original GG-1 was produced with a riveted body. Industrial designer Raymond Loewy redesigned the locomotive by having the entire exterior body welded rather than using rivets. He also designed the elegant gold striping that ran the length of the body. This lettering was hand-applied and coated with a special lacquer.

With the GG-1, the Pennsylvania Railroad had one of the best operating electric locomotives ever built, and its classic design was awe-inspiring. The PRR was proud of its GG-1s and used images of the locomotive in substantial amounts of promotional material. Photographs and drawings of the GG-1 appeared on annual reports, wall calendars, timetables, and advertisements. The railroad took pride in showing off the GG-1s at the Army-Navy football games in Philadelphia, lining them up for photo ops. One of the GG-1s was put on display at the 1939 New York World's Fair in Queens, and another at the 1948 Chicago Railroad Fair.

The GG-1 was famous beyond railroad circles too. The Topps Chewing Gum Company had an image of a GG-1 in its 1955 Rails and Sails series. In 1999, the US Postal Service produced a 33¢ stamp with an image of a GG-1 heading up the *Congressional* train. The GG-1 was one of the few locomotives in railroad history to have a formal ceremony when it was retired from service by New Jersey Transit on October 29, 1983.

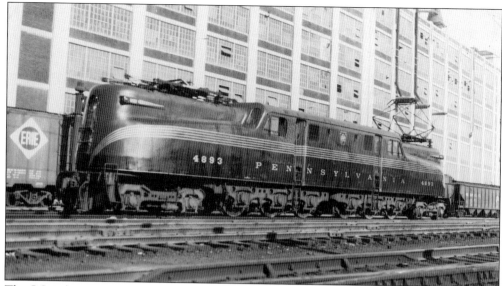

The GG-1 electric locomotive was the workhorse of the Pennsylvania Railroad's fleet of passenger trains in the Northeast corridor. 139 of these locomotives were built between 1934 and 1943. The GG-1 operated bidirectionally, with an operating cab in the center for crew safety. No. 4893 is seen here at Sunnyside Yard on December 1, 1949. (Author's collection.)

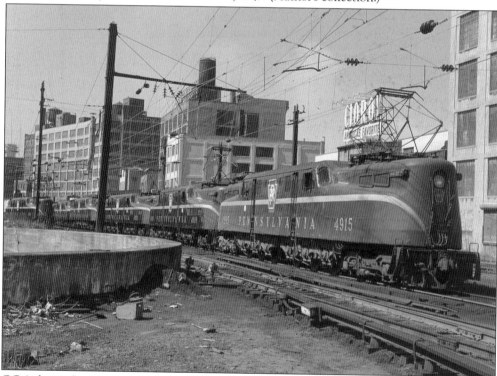

GG-1 electric locomotives were a common sight in Sunnyside Yard for nearly 50 years from 1934 to 1983. These engines pulled famous Pennsylvania Railroad passenger trains including the *Broadway Limited* and the *Congressional*. To the left is the wall of the little used turntable that was a short distance east of the engine house. (Vincent Alvino photograph, courtesy of Jim Mardiguian.)

The engine house, seen at right, provided light servicing of the electric locomotives that arrived in the yard. In this 1970s view, a dozen or more GG-1 locomotives are laid up on tracks beside the engine house. The Lighthouse Industries (for the blind) building is in the left background. Most of the buildings in the area have rooftop water storage tanks. (Courtesy of Jim Mardiguian.)

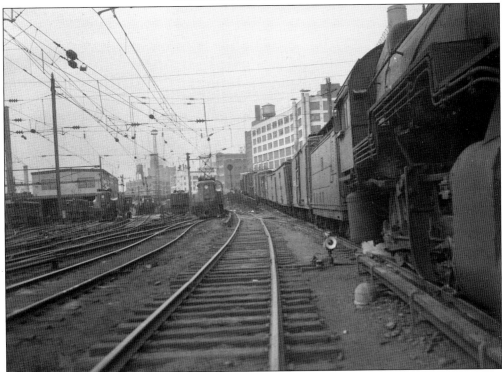

A Long Island Rail Road H-10 steam locomotive is pushing a string of freight cars over the hump into Yard A. At left is the east end of the engine house with several B-1 and GG-1 electric locomotives outside. Third rails can be seen at several locations in this April 10, 1943, photograph by Fred J. Weber. (Author's collection.)

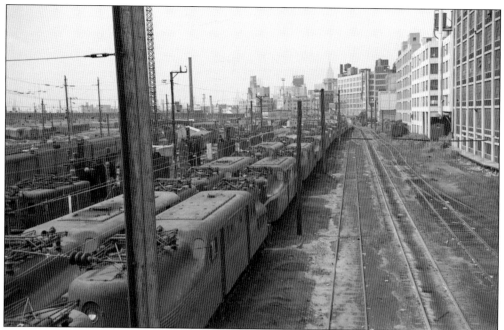

Looking west from the Thirty-ninth Street overpass on September 5, 1960, an abundance of GG-1 locomotives are laying up end-to-end as far as the eye can see. In the far left background, curving away from the locomotives, is the passenger coach yard. (Will V. Faxon Jr. photograph, courtesy of David Keller.)

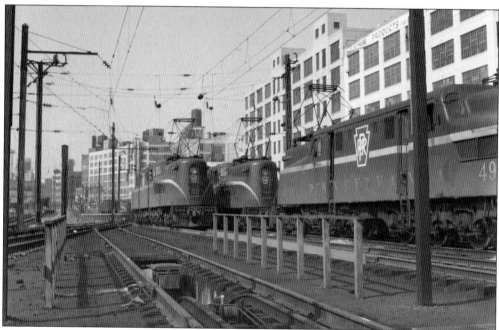

Three GG-1 locomotives, with raised pantographs, are on the ready track. This photograph illustrates how close the industrial buildings were to the north side of Sunnyside Yard. Note the PRR overlapping letters within the keystone emblem on the side of the GG-1 at right. (Courtesy of David Keller.)

A deadhead (equipment only) passenger train, with a GG-1 locomotive at the head end, is heading from Sunnyside Yard onto Line No. 2 of the East River Tunnels to enter Penn Station. It is a summer Friday afternoon in 1969 and an LIRR passenger train is in sight at Hunters Point Avenue Station. That train will bring passengers to the east end of Long Island at Montauk. (Courtesy of Jim Mardiguian.)

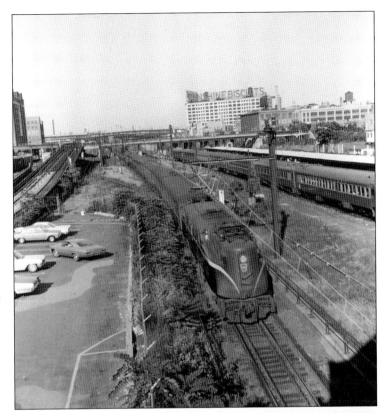

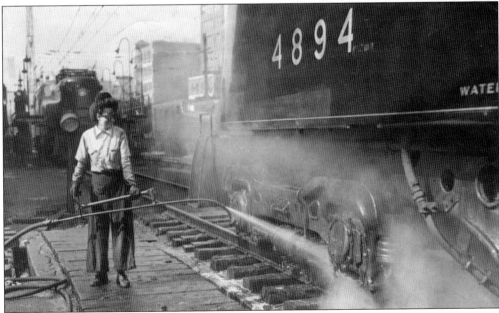

During World War II, the railroads hired many women to perform tasks due to the shortage of men who were off fighting the war. In this photograph, a woman is seen spray washing the wheels and truck assembly of a GG-1 locomotive. During the war, the PRR still maintained a high degree of respect for the appearance of its equipment. (Courtesy of John Turkeli.)

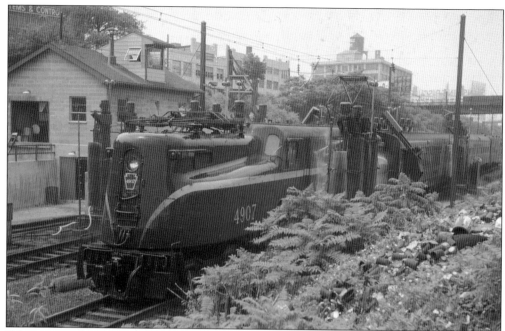

When trains destined for Sunnyside Yard came out of Penn Station, they first went through a wash that was located behind Harold Tower. Trains would go through under their own power at three to five miles per hour. An 18-car train could be washed in 10 to 15 minutes. As the trains moved through the wash, streams of hot water and detergent were squirted onto the equipment as brushes from multiple directions scrubbed the cars clean. The locomotives got washed here, but there was also a wash at the engine house that did a more thorough job. (Above, Vincent Alvino photograph, courtesy of Jim Mardiguian; below, courtesy of John Turkeli.)

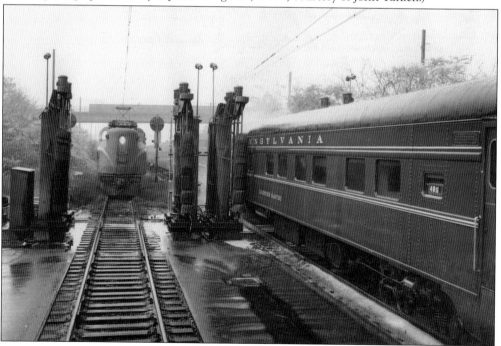

The cover of the May 1948 *Railroad* magazine had a painting of a GG-1 locomotive going through the wash at the engine house. This illustration showed the distinctive types of brushes that were designed to scrub the hard-to-reach places on a GG-1 locomotive. Locomotives were pulled through this wash by a trolley system due to the risk of high electrical current. (Courtesy of *Railfan & Railroad* magazine.)

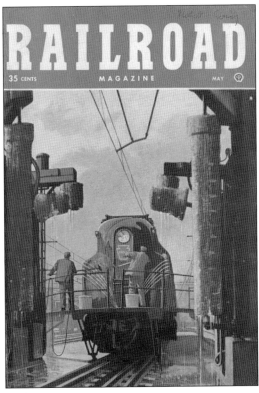

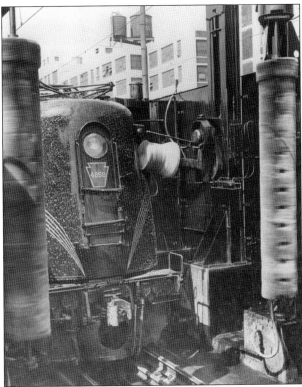

This view shows the head end of a GG-1 locomotive as it proceeds into the wash. The wash, which was new in 1948, formed a gauntlet 15 feet high on each side. The wash was capable of scrubbing, rinsing, and polishing 100 locomotives in a 24-hour period. This was in the days when the Pennsylvania Railroad took great pride in the appearance of its trains. (Courtesy of John Turkeli.)

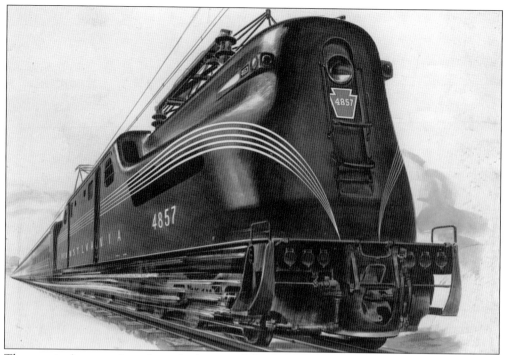

These artists' conceptions show the beauty of the GG-1 locomotive exterior and cab interior. Above, No. 4857 shows off its five widely spaced pinstripes and keystone number plate as it whisks along the track. Below is the view that an engineer would have as he approached a clear signal. The GG-1s were equipped with cab signal indicator lights, seen at left next to the gauges. (Both, courtesy of John Turkeli.)

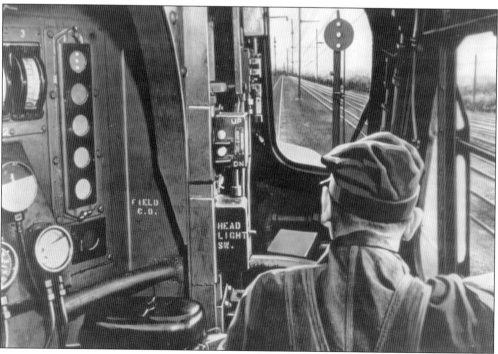

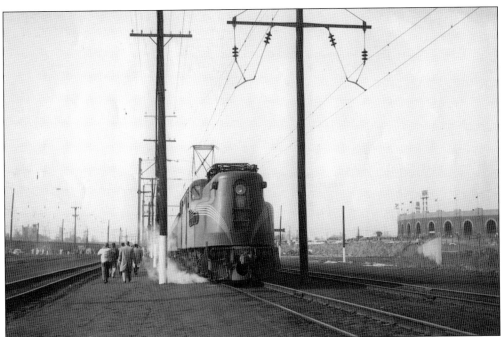

For 40 years beginning in 1936, the Pennsylvania Railroad ran football specials to the Army-Navy game at Municipal Stadium in Philadelphia. The first year the railroad ran 38 trains to the game. A record was set in 1941 with 42 trains. Due to World War II, there were no Army-Navy games for three years, resuming in 1945. At top, the Municipal Stadium can be seen at right. Below, a lineup of five GG-1 locomotives await the end of the game in November 1953. These locomotives were lined up for all to see, and the railroad made sure that they were spotless. (Both, courtesy of John Turkeli.)

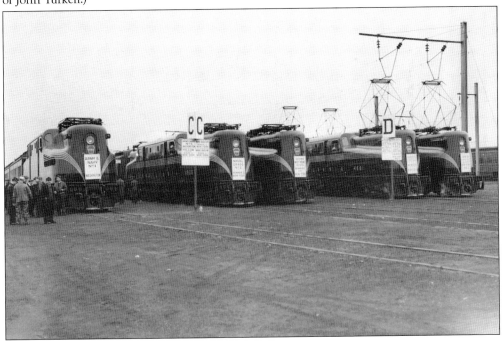

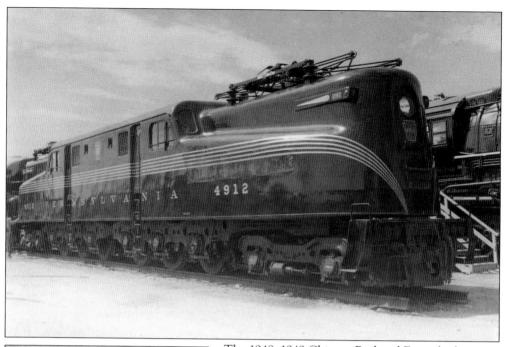

The 1948–1949 Chicago Railroad Fair, which was held along the shore of Lake Michigan, has been often referred to as "the last great railroad fair." 39 railroads participated, as did 20 equipment manufacturers, including General Motors. The Pennsylvania Railroad displayed GG-1 No. 4912, seen here next to a steam locomotive. (Author's collection.)

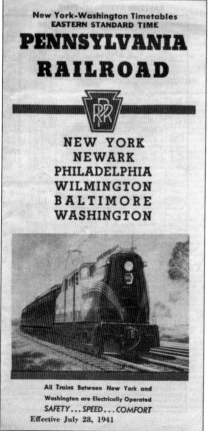

New York-Washington Timetables
EASTERN STANDARD TIME

PENNSYLVANIA RAILROAD

NEW YORK
NEWARK
PHILADELPHIA
WILMINGTON
BALTIMORE
WASHINGTON

All Trains Between New York and
Washington are Electrically Operated
SAFETY...SPEED...COMFORT
Effective July 28, 1941

The Pennsylvania Railroad used images of the GG-1 on many of its timetables including this July 28, 1941, New York–Washington timetable boasting "All Trains Between New York and Washington are Electrically Operated SAFETY. . . SPEED . . . COMFORT." The keystone number plate was pictured in red on this timetable. (Author's collection.)

GG-1 No. 4938 was pictured in a painting by famous railroad artist Grif Teller on the cover of the Pennsylvania Railroad 1948 Annual Report. This painting, which was titled, "Main Lines, Freight and Passenger," shows a westbound passenger train rushing east from Harrisburg toward New York as it goes under the Trenton Cutoff Bridge in Whitford, Pennsylvania. The GG-1 stands out in stark relief. (Author's collection.)

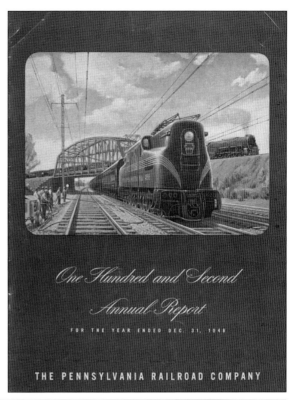

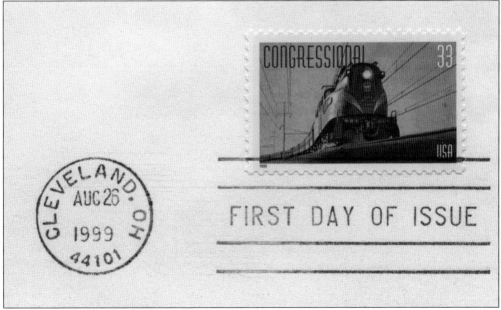

In 1999, the US Postal Service issued a set of five 33¢ stamps featuring paintings by noted railroad artist Ted Rose. Designated the "All Aboard" series, one of the stamps featured a Pennsylvania Railroad GG-1 locomotive at the head end of the *Congressional* train between New York and Washington. Text on the reverse side of the stamp indicated that in 1935, designer Raymond Loewy improved the looks of the GG-1 locomotives. (Author's collection.)

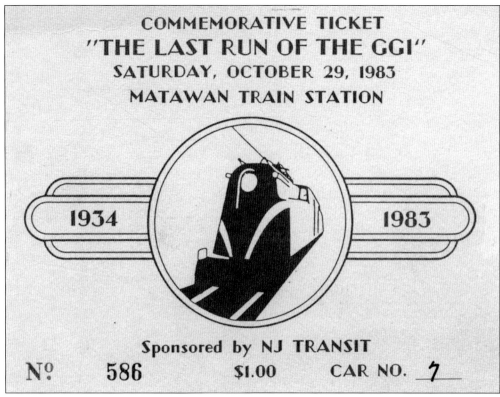

COMMEMORATIVE TICKET
"THE LAST RUN OF THE GG1"
SATURDAY, OCTOBER 29, 1983
MATAWAN TRAIN STATION

1934 1983

Sponsored by NJ TRANSIT

Nº 586 $1.00 CAR NO. 7

Very few locomotives have enjoyed the honor of having a formal retirement ceremony, but the GG-1 was an exception. On Saturday, October 29, 1983, New Jersey Transit sponsored train rides to Matawan Station where a ceremony was held to commemorate the nearly 50 years of service performed by the GG-1 and to mark their retirement from service. Railroad officials referred to the GG-1 as a "Champion." Above is a commemorative ticket, and below, No. 4877 is seen at Matawan. (Both, author's collection.)

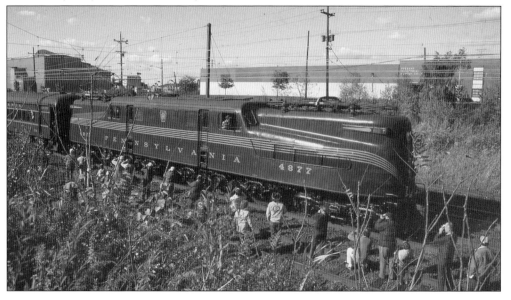

Seven

INTERLOCKING
SIGNAL TOWERS

*A properly planned track layout and interlocking arrangement will go far
toward insuring operation with proper regularity and punctuality.*

—John A. Droege

An interlocking is an arrangement of switches and signals that ensure that only the proper signals can be displayed for any route that is set up for a train movement. During the 1950s, the operation at Sunnyside Yard was massive, with 53 total track miles and 296 switches. The switches were controlled by the tower employees, who worked three shifts every day of the week.

At Sunnyside Yard the interlocking system was controlled from four two-story brick interlocking towers. The Pennsylvania Railroad controlled the following three towers:

R Tower, located at the northeast side of the yard, west of the Thirty-ninth Street overpass, controlling the tracks through the Loop Wash, the loop tracks, and the entrance into the yard tracks.

Q Tower, located at the southwest side of the yard, east of the Queens Boulevard overpass, controlling the exit from yard to the tunnel tracks.

F Tower, located farther west of Q Tower, just west of the Thompson Avenue overpass, controlling the approaches to tunnels themselves.

The fourth tower, Harold Tower, is controlled by the Long Island Rail Road. It is on the LIRR main line between Honeywell Avenue and Thirty-ninth Street. It controls the track interchanges between the LIRR and Amtrak. Harold Interlocking is the busiest intersection of tracks in the country, with 600 LIRR trains and 48 Amtrak trains passing through it daily.

Today, there are not many interlocking towers on American railroads. Most interlocking systems are controlled by computerized central traffic control systems. In the case of Sunnyside Yard, all of the switches and signals are now controlled by the Penn Station Central Control facility located a block west of Penn Station. This facility is jointly managed by the Long Island Rail Road and Amtrak.

This c. 1920 wide-angle photograph looking east shows Q Tower to the left. Q Tower controlled the switches and signals at the west end or exit of the yard. The commissary building is in the center distance, and the coach yard is off to the right. Note the absence of catenary wires. (Courtesy of David Keller.)

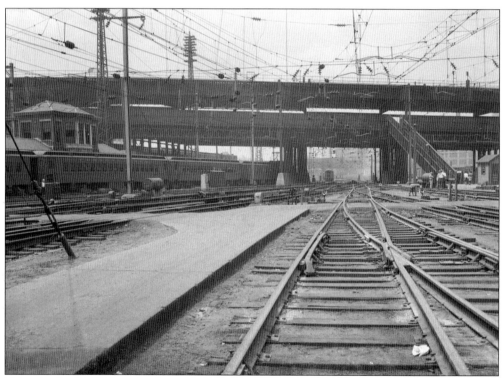

Taken by Fred J. Weber, this June 16, 1943, photograph shows Q Tower at left. The overpass is the Queens Boulevard Viaduct, with a stairway going from the yard up to street level. The No. 7 subway line runs on the top level of the viaduct. Catenary wires, installed in 1932, can be seen in this view. (Author's collection.)

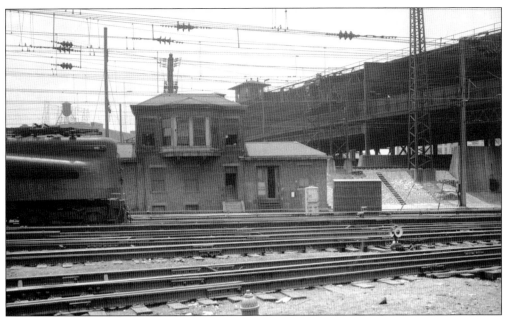

This June 16, 1943, Weber photograph gives a good view of the front of Q Tower, with a GG-1 locomotive at left. It was at Q Tower that locomotives departing from the engine house would make a reverse move and couple to their appropriate trains in the yard. (Author's collection.)

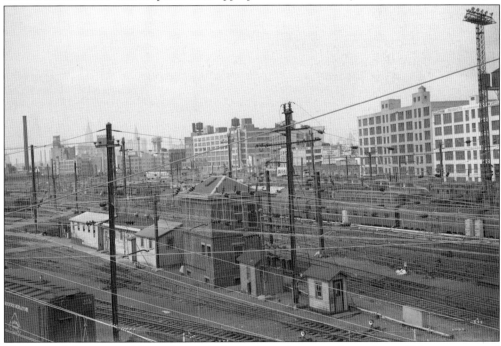

The rear of the towers did not have windows, since the control panels would have prevented any outside view in that direction. This September 1960 view of R Tower shows the rear of the structure. R Tower controlled the movement of trains coming off of the loop tracks into the assigned yard tracks. This photograph was taken from the Thirty-ninth Street overpass. (Courtesy of David Keller.)

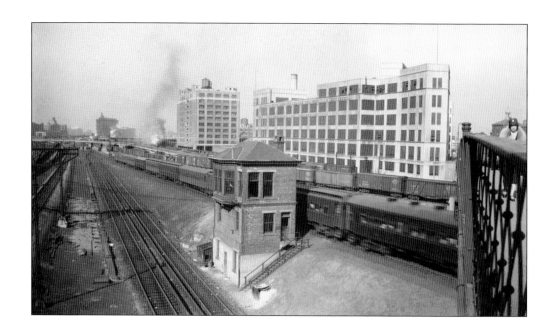

F Tower, which is located slightly west of the Thompson Avenue overpass, controls the approach tracks to the East River Tunnels. The above 1921 view from the overpass shows both a passenger train and a freight train beyond the rear of the tower. Note the absence of catenary wires. The below 1973 view shows an LIRR M-1 train in the background with the catenary wires prevalent in the foreground. (Both, courtesy of David Keller.)

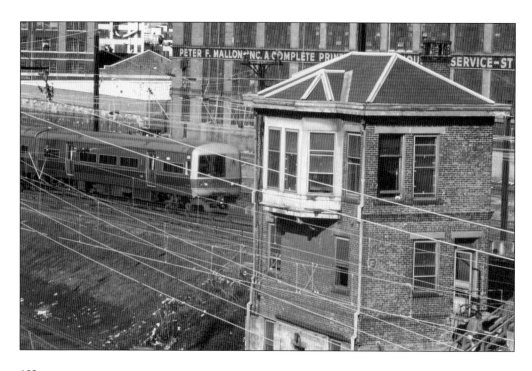

Harold Tower was quite different from the other three towers in that it was not controlled by the Pennsylvania Railroad but rather the Long Island Rail Road (albeit the LIRR was under the auspices of the PRR). Harold Tower is on the LIRR main line between Honeywell Avenue and Thirty-ninth Street. This tower controls the track interchanges between the LIRR and the New York Connecting Railroad and Amtrak. This tower was pictured on the cover of the July 1951 LIRR employee newsletter *Long Island Railroader.* Note the keystone sign with "Harold" on the side wall. Below is a 1978 photograph of the tower with awnings over the trackside windows. (Right, author's collection; below, courtesy of David Keller.)

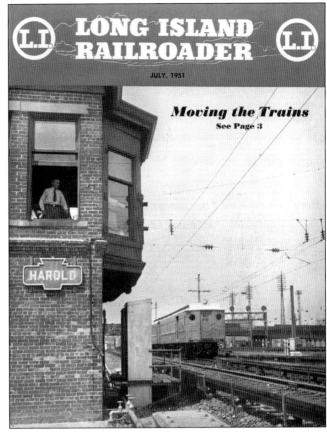

L.I. **LONG ISLAND RAILROADER** L.I.

JULY, 1951

Moving the Trains
See Page 3

HAROLD

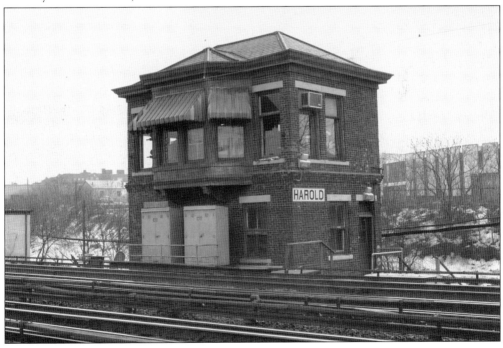

HAROLD

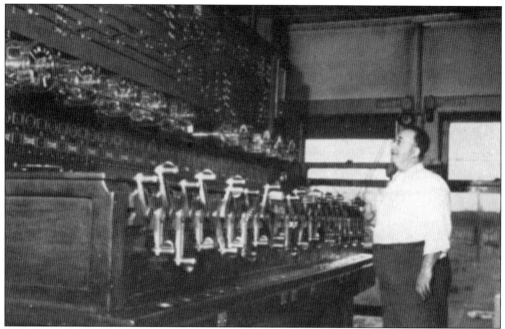

Inside Harold Tower, leverman C.H. McClain is at the 47-lever interlocking machine, which controls 18 switches for 8 tracks through the busy interlocking. When this photograph was taken in 1951, Harold Tower handled the movement of 546 trains on a daily basis. Harold was the division point for the PRR New York Division and for the New Haven Railroad. (Author's collection.)

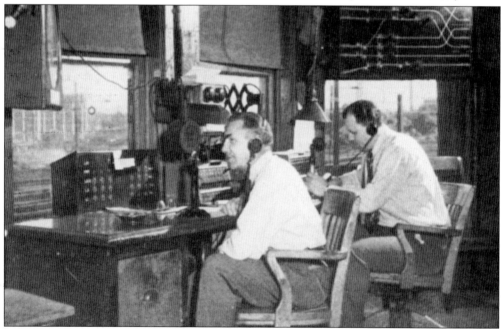

In another 1951 Harold Tower interior view, train director V.M. Kobelski (left) and block operator E.W. Pierkarski are seen at the control desk. One of their main duties was to report the passage of trains to the dispatcher in Jamaica, as well as to dispatchers on the PRR and New Haven Railroad. (Author's collection.)

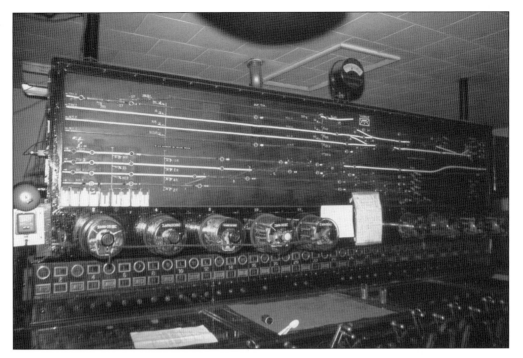

These two March 12, 1978, photographs show close-up views of the Harold Tower interlocking machine. The above view shows the model board, which has a diagram of the tracks, switches, and signals under the control of the tower. The below view shows the levers that are thrown by the leverman to control train movements through the interlocking. (Both, courtesy of David Keller.)

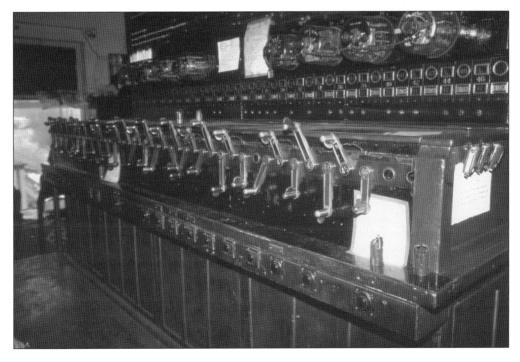

In addition to controlling one of the busiest railroad interlockings in the country, Harold Tower personnel were given duties of controlling the Great Neck interlocking on the Port Washington Branch. That interlocking was controlled by a tabletop machine inside the Great Neck ticket office. The undated photograph above shows the Great Neck ticket office with the track model board at upper left. Below is a photograph of the five-lever mini-lever control panel that was placed into service at Harold Tower on February 21, 1963, to control Great Neck interlocking. (Both, courtesy of David Keller.)

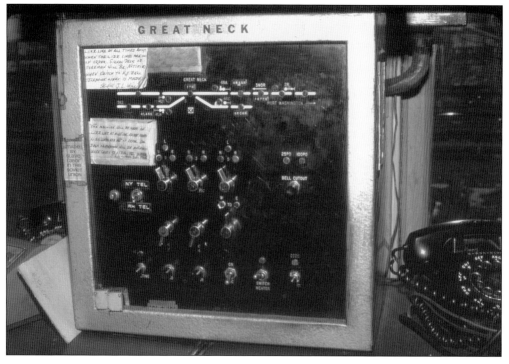

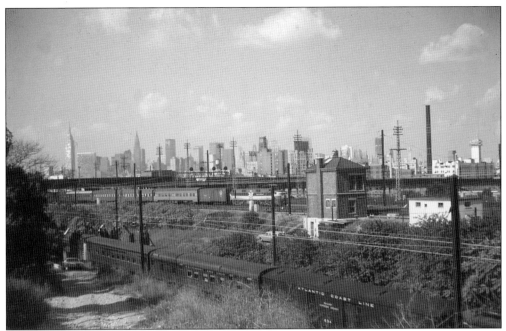

This October 13, 1967, photograph looks northwest showing the rear of Harold Tower with the New York City skyline in the background. An eastbound New Haven Railroad train can be seen going through Harold Interlocking headed toward the Hell Gate Bridge. In the foreground, a train is going through the wash, with an Atlantic Coast Line express car at bottom right. (Author's collection.)

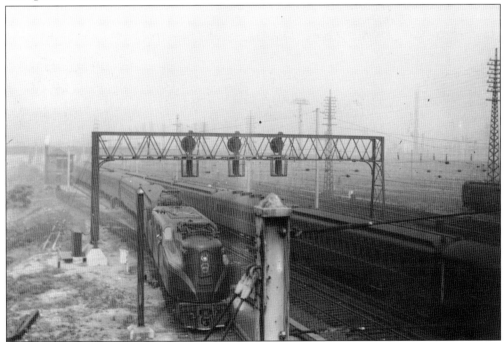

GG-1 Locomotive No. 4872 is seen in this June 12, 1938, photograph leading a passenger car consist onto the loop tracks and into the yard. Harold Tower can be seen in the left background. The signal bridge has three position light signals on it. (Author's collection.)

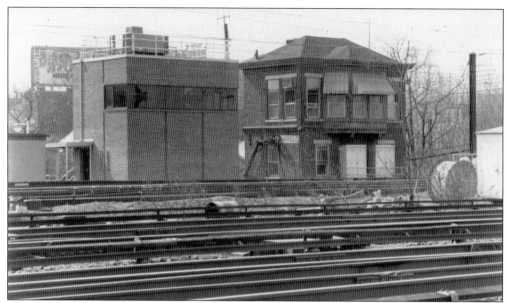

Harold Interlocking was constructed in 1910 to control the movement of trains from the East River Tunnels to the Long Island Rail Road main line, the New York Connecting Railroad movements, and the New Haven Railroad trains (now Amtrak trains) going across the Hell Gate Bridge to New England. In 1990, the interlocking was reconstructed, and a new signal tower was built. In this photograph, the new tower is seen at left adjacent to the 1910 tower. The older tower was demolished in the 1990s. (Courtesy of Long Island Rail Road.)

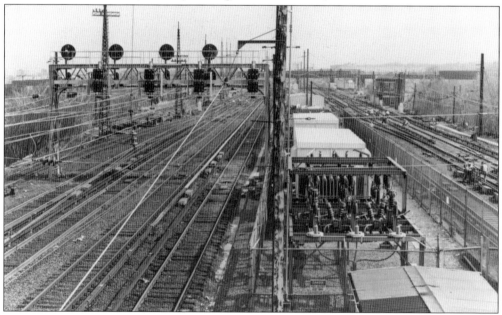

Looking east, the 1910 Harold Tower building can be seen at right. Extending across four tracks is the signal bridge that controls the bidirectional signal system. To the right of the signal bridge is the hut that controls part of the new signal system that was installed in 1990. Maintenance-of-way employees can be seen at right performing track reconstruction work. (Courtesy of Long Island Rail Road.)

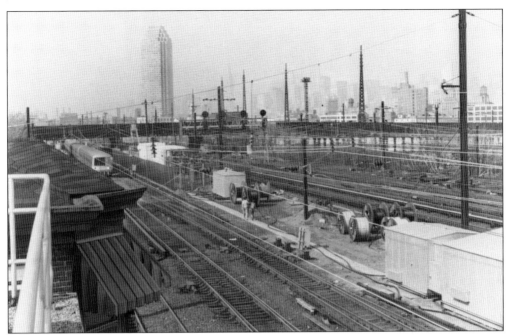

With the skyline of Manhattan visible in the background, an eastbound LIRR multiple-unit electric train makes its way through Harold Interlocking in 1990. This interlocking is one of the most congested railroad interlockings in the United States. Over 650 trains pass through these tracks daily. (Courtesy of Long Island Rail Road.)

The 1990 Harold Interlocking reconstruction project came through on time and under budget, surely a reason for the LIRR to celebrate. In this photograph, the old Harold Tower sign was presented to LIRR president Charles W. Hoppe, pictured in the center of this group. This photograph was published in the September 1990 issue of the employee newspaper *Along the Track*. (Courtesy of Long Island Rail Road.)

On June 2, 1994, the Claytor-Scannell Control Center, a few blocks from Penn Station, was dedicated. Also known as Penn Station Central Control, this facility is jointly administered by the Long Island Rail Road and Amtrak. This facility replaced the 80-year old signal towers of Penn Station and Sunnyside Yard. Operating levers in the old towers were replaced by a computerized system. (Courtesy of Long Island Rail Road.)

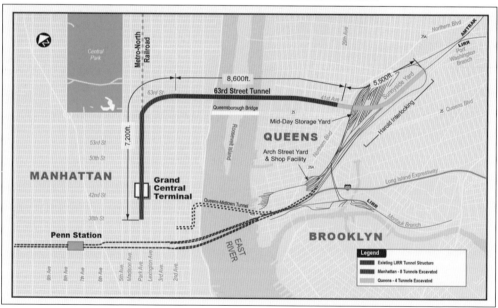

The LIRR has plans to enter Grand Central Terminal by 2023. This will require tunneling under Sunnyside Yard to get to the Sixty-third Street Tunnel and from there south under Park Avenue to a new station being built underneath Grand Central Terminal. This diagram shows where the tunnel will go underneath Sunnyside Yard starting from Harold Interlocking. (Courtesy of Ray Kenny.)

Eight

HELL GATE BRIDGE

The towers . . . helped to give the bridge a monumental appearance, and their massive size conveyed a feeling of the solidity that was needed to contain the thrust of the great arches.

—William D. Middleton

The final phase of the Pennsylvania Railroad's New York Extension was the Hell Gate Bridge, connecting the New England states with Penn Station, as well as with a float bridge operation for railroad freight destined for the Greenville Yard in New Jersey. The treacherous water currents in the area where the bridge would be built was known as Hell Gate, which is how the bridge was named. The New Haven Railroad joined the PRR in forming the New York Connecting Railroad, under which the bridge and the rail route to Bay Ridge, Brooklyn, were constructed.

Upon completion of the New York Connecting Railroad (NYCR), New Haven Railroad passenger trains had a direct route from Connecticut into Penn Station. Also, freight trains could go over the NYCR route to the float bridges at Bay Ridge. There, the freight cars were loaded onto car floats (barges with railroad tracks on the deck) for transport to the Greenville Yard in New Jersey for classification and dispatching to points south and west.

The construction of the Hell Gate Bridge was a monumental undertaking. Famous bridge builder Gustav Lindenthal was chosen to design and build the bridge. He built the Queensboro Bridge linking Long Island City with Manhattan, which opened in 1909 (that bridge is now officially known as the Ed Koch Bridge). He was known for building bridges that were aesthetically pleasing as well as being made for their operational purpose.

The length of the entire bridge, including the approach viaducts, is a bit over three miles from the Long Island abutment to the Bronx abutment. The viaduct on the north side was a wide-sweeping curve that passed over Wards Island and Randalls Island. The main span consisted of two monumental stone towers that supported a steel arch structure wide enough for four railroad tracks. The distance between the towers is 1,017 feet. It was surely an impressive structure.

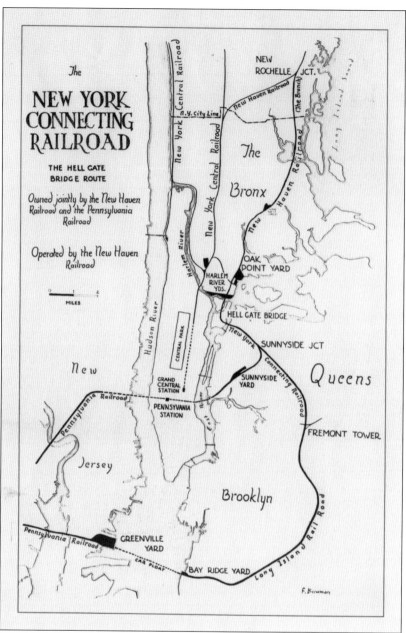

The second phase of the Pennsylvania Railroad's New York Extension was the completion of the New York Connecting Railroad in 1917. This railroad would serve as a bridge line between the PRR and the New Haven Railroad. It would allow New Haven Railroad passenger trains direct access into Penn Station and would allow freight train movements between Oak Point Yard in the Bronx and the Bay Ridge Yard in Brooklyn. From Oak Point, the freight trains would travel over the Hell Gate Bridge to Bay Ridge and from there cross the Hudson River to the PRR's massive Greenville Yard. This map shows the route of the NYCR and the passenger train route to Sunnyside Yard, Penn Station over to New Jersey. Shown on the map is Fremont Tower, where there was an interchange with the Long Island Rail Road and the New Haven Railroad. For simplicity, portions of LIRR trackage are not shown on this map. (Author's collection.)

The Hell Gate Bridge is pictured on this 1940 bond certificate of the New York Connecting Railroad. The NYCR was incorporated in 1892, but little funding was raised for the project. In 1902, the Pennsylvania Railroad purchased controlling interest in the company and almost immediately sold half of the stock to the New Haven Railroad. Both railroads would be responsible for laying the track and building the bridges to complete the railroad from Oak Point Yard to Bay Ridge Yard. (Author's collection.)

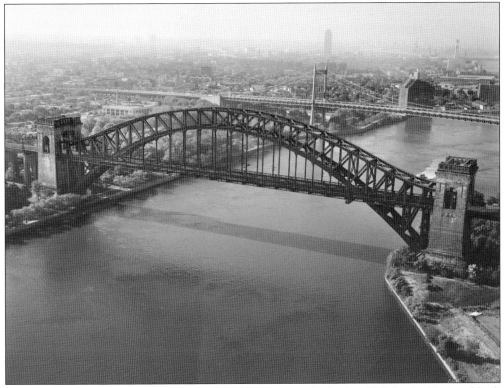

The Historic American Engineer Record (HAER) was established in 1969 by the National Park Service, the American Society of Civil Engineers, and the Library of Congress to document historic sites and structures related to engineering and industry. One of the HAER photographs is this view of the Hell Gate Bridge looking southwest with the Triborough Bridge in the background. The Triborough Bridge, completed in 1926, has been formally named the Robert F. Kennedy Bridge since 2008. (Courtesy of the Library of Congress.)

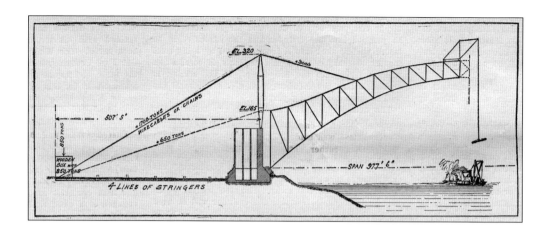

The Hell Gate Bridge has three sections: Wards Island Tower, a steel span, and the Long Island Tower. The steelwork was constructed from each tower to meet in the middle. Cables and counterweights allowed the traveling cranes to erect the steel without any supporting falsework below. The above drawing, which appeared in the June 8, 1907, issue of *Scientific American*, shows the arrangement of the anchorage, the 850-ton counterweight, and the cables used while erecting the steel arch. The photograph below, taken on the Wards Island site on August 18, 1915, shows a traveling crane raising a piece of steel for placement in the arch. (Both, author's collection.)

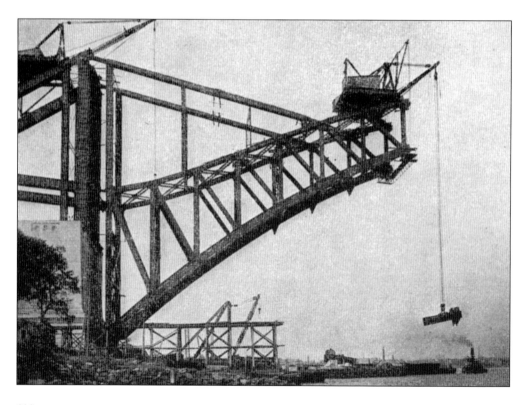

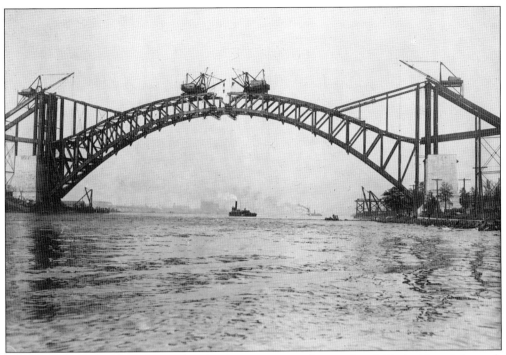

These photographs show the steel arch when it was nearly completed. Both sides of the arch met on October 1, 1915, and there was only a quarter-inch variation. After the connection was made, the cables and counterweights were removed, and the bridge arch supported itself. (Both, courtesy of the Library of Congress.)

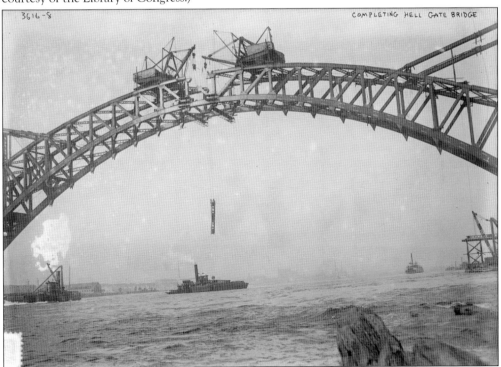

115

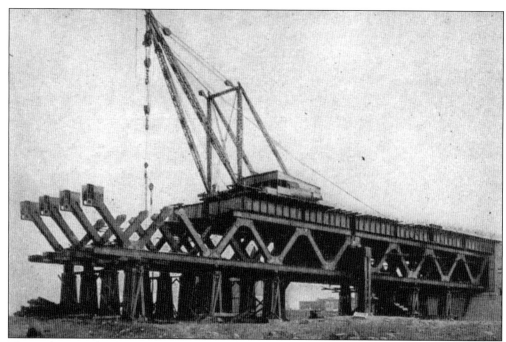

These photographs show traveling cranes erecting steel on the Long Island approach viaduct. This viaduct was 3,480 feet long, supported by retaining wall embankments with concrete arches and steel bridges crossing over public streets. The clearances from the streets ranged from 30 to 65 feet. (Both, author's collection.)

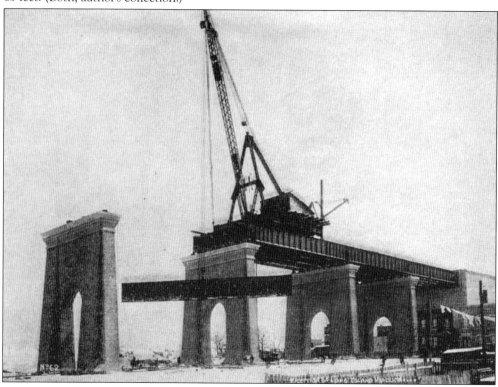

This is a rare photograph dated October 12, 1914, showing a few dozen workmen, obviously posing for the camera, standing in front of a traveling crane on the Hell Gate Bridge. No names are known. Sadly, five men died during the construction work. (Author's collection.)

Two traveling cranes are seen in this undated photograph; the cranes placed a large section of steel into the Randalls Island Viaduct. All of the steel for the arch and the smaller bridges was fabricated at the American Bridge Company in Pittsburgh and transported by rail to the PRR Greenville Yard for temporary storage until needed for the construction work. (Courtesy of the Library of Congress.)

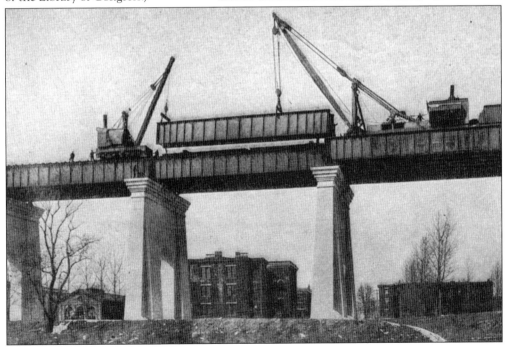

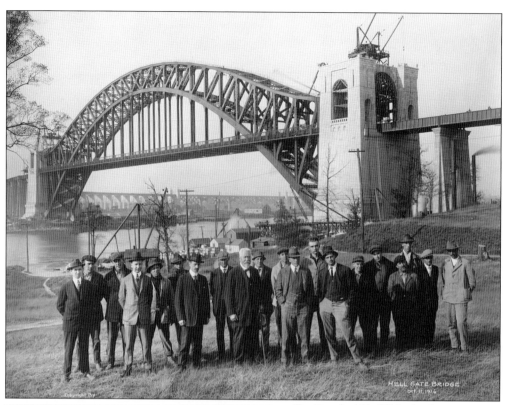

On October 11, 1916, chief engineer Gustav Lindenthal (center, without hat), along with his engineering staff, posed in front of the nearly completed Hell Gate Bridge. This photograph, taken on the Long Island side, shows a crane doing some completion work on top of the tower. (Courtesy of the Library of Congress.)

Gustav Lindenthal was a bridge designer whose works included the Queensboro Bridge (also known as the Fifty-ninth Street Bridge or the Ed Koch Bridge), which opened in 1909. The Pennsylvania Railroad chose him to design the Hell Gate Bridge, which was to be of artistic design as well as utilitarian construction. Born in 1850, Lindenthal passed away in 1935. (Courtesy of the Library of Congress.)

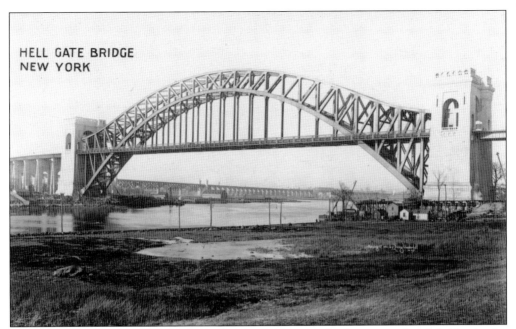

At the time of its construction, the Hell Gate Bridge was the largest steel arch bridge in the world, measuring 1,017 feet between the towers. The arch rises 170 feet above the East River. (Author's collection.)

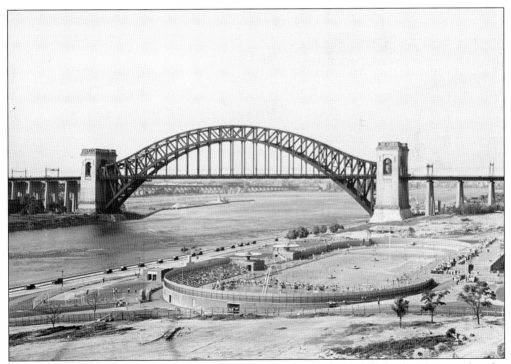

This July 7, 1936, view of Hell Gate Bridge looks east with the Astoria Park swimming pool in the foreground. This park, consisting of 60 acres adjacent to the Triborough and Hell Gate Bridges, is one of the largest open areas in Queens. (Author's collection.)

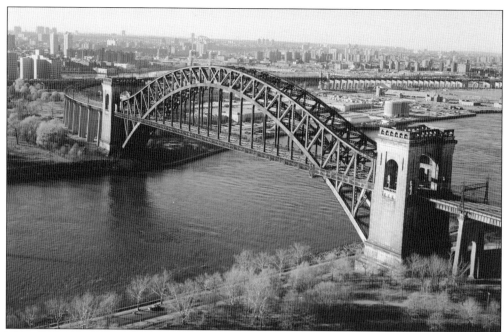

These two aerial photographs show the Hell Gate Bridge from different vantage points. The photograph above looks northeast with the long Bronx approach viaduct curving to the right. This viaduct went across Wards Island, Little Hell Gate, Randalls Island, and the Bronx Kills. The photograph below looks southeast and shows the Long Island approach viaduct going off to the right. The entire length of the bridge structure and approach viaducts is three miles from the Bronx Viaduct to the Long Island Viaduct. (Both, courtesy of the Library of Congress.)

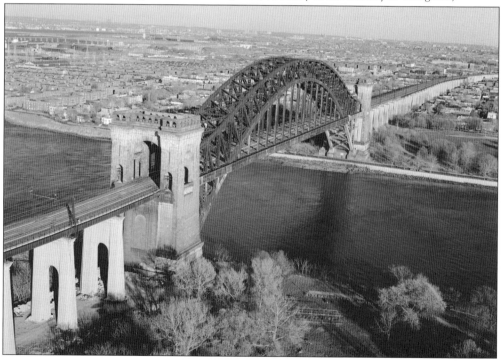

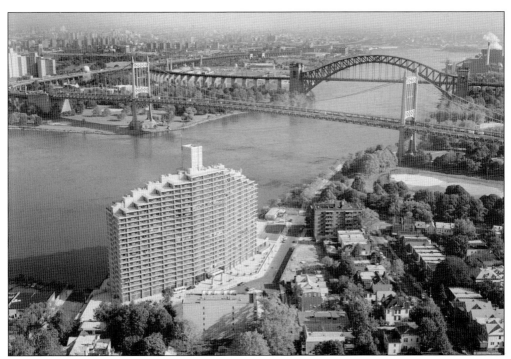

These two aerial photographs show the Triborough Bridge in the foreground, with the Hell Gate Bridge in the background. The former is the roadway for Interstate 278. Due to their close proximity, travelers on the Triborough Bridge can get a good view of the Hell Gate Bridge. In the far distance, beyond the Hell Gate Bridge, the smokestacks of the Astoria Generating Station can be seen. (Both, courtesy of the Library of Congress.)

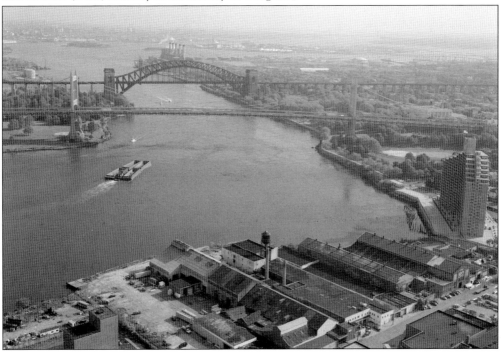

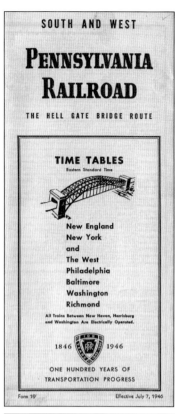

SOUTH AND WEST

PENNSYLVANIA RAILROAD

THE HELL GATE BRIDGE ROUTE

TIME TABLES

Eastern Standard Time

New England
New York
and
The West
Philadelphia
Baltimore
Washington
Richmond

All Trains Between New Haven, Harrisburg
and Washington Are Electrically Operated.

1846 1946

ONE HUNDRED YEARS OF
TRANSPORTATION PROGRESS

Form 19 Effective July 7, 1946

The Pennsylvania Railroad boasted of "the Hell Gate Bridge Route" on this July 7, 1946, public timetable. The timetable also noted that "all trains between New Haven, Harrisburg and Washington are electrically operated." There was also an emblem and message noting that the PRR was in its 100th anniversary year. (Author's collection.)

This photograph, looking west, shows the Hell Gate Bridge in the foreground and the Triborough Bridge, under construction, in the background. Work began on the Triborough on October 25, 1929, and the bridge was dedicated on July 11, 1936, dating this photograph to sometime in the early 1930s. (Author's collection.)

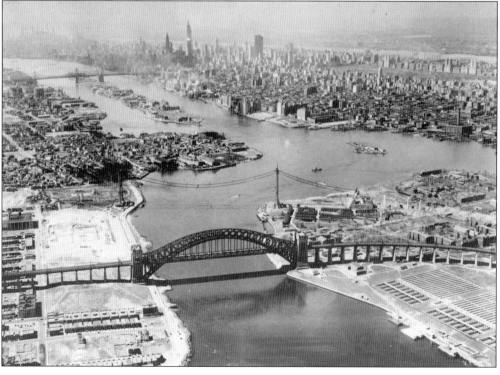

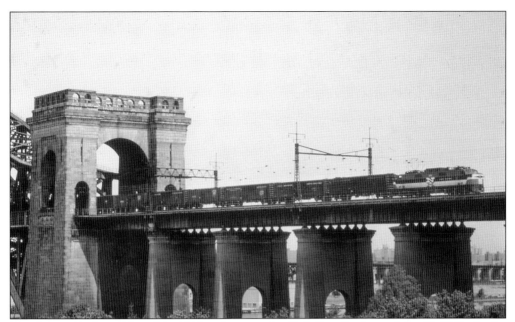

New Haven Railroad Train No. 181 heads across the Hell Gate Bridge on May 25, 1968. At the head end is an EP-5 double-ended electric locomotive, which ran between Penn Station and New Haven, Connecticut. Equipped with two pantographs, it was always the rear pantograph that was raised to the catenary wires. (Courtesy of John Turkeli.)

Track Geometry Car TC-80 crosses the Hell Gate Bridge in May 1988 en route to New Rochelle, New York, to perform track testing on the Metro North Railroad. This vehicle was used to test track on the LIRR and MN twice a year. It could detect internal flaws in rails that would not be visible to the naked eye. (Courtesy of Gene Collora.)

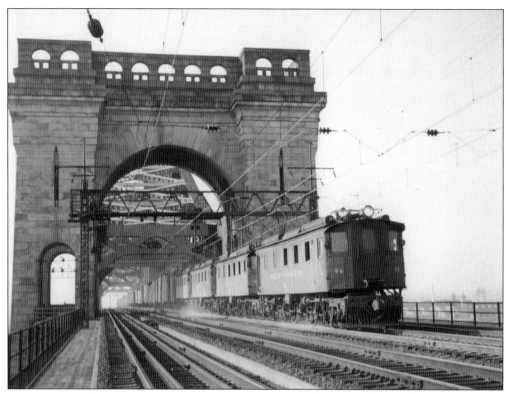

Four New Haven Railroad class EF-1 electric locomotives power westbound freight train NG-1 through the east arch of Hell Gate Bridge on March 14, 1953. The train is headed toward Bay Ridge, where the cars will be transported by car floats to the Pennsylvania Railroad yard in Greenville, New Jersey. (Courtesy of Gene Collora.)

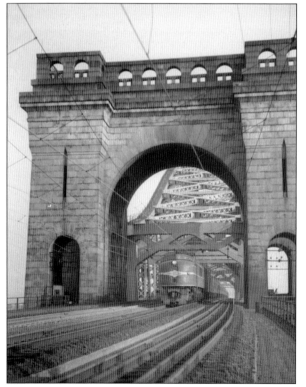

A New Haven Railroad passenger train on a Washington-to-Boston run crosses over the Hell Gate Bridge. This train is being hauled by an EF-3 class electric locomotive. Built for freight service in 1942, these locomotives were equipped with train-heating boilers in 1948 to allow them to be used in passenger service. (Courtesy of Gene Collora.)

131:—AIRPLANE VIEW OF THE TRIBOROUGH
AND HELL GATE BRIDGES, NEW YORK.

This postcard, included in a series of postcards promoting the 1939 New York World's Fair, shows an aerial view of the Triborough and Hell Gate Bridges. The reverse side notes that the Triborough Bridge unites three of the boroughs of Greater New York: Bronx, Queens, and Manhattan. (Author's collection.)

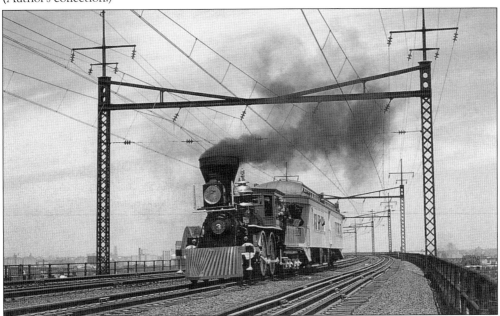

This is a famous locomotive coming across a famous bridge. The Civil War locomotive the *General* traveled under its own power across the Hell Gate Bridge en route to the 1964 New York World's Fair. This locomotive appeared on a 29¢ US postage stamp issued in 1994, and was featured in the 1926 silent movie *The Great Locomotive Chase* as well as the 1956 remake of the movie by Walt Disney Studios. (Courtesy of Walter Zulig.)

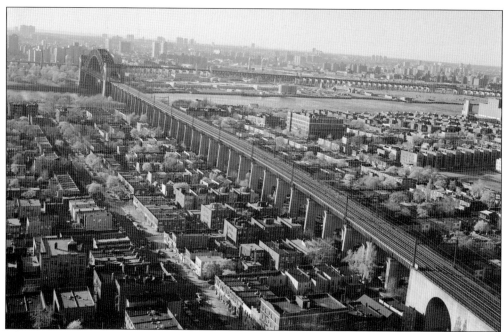

These two photographs show the approaches to the Hell Gate Bridge. Above is the Long Island approach looking northeast. The concrete arch at lower right is the Twenty-ninth Street arch, the narrowest of all the arches. The other arches on the Long Island side are at Thirty-first, Thirty-third, Thirty-seventh, and Thirty-eighth Streets. Seen below is the curved Wards Island approach looking southwest. The four inverted bowstring truss structures underneath the tracks are for the Little Hell Gate Bridge that spanned the channel between Wards Island and Randalls Island. In the early 1960s, this channel was filled in. (Both, courtesy of the Library of Congress.)

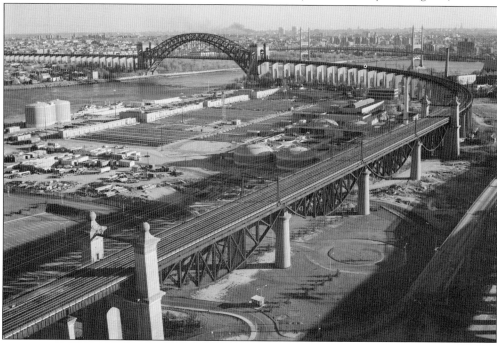

In the late 1990s, an eastbound Amtrak passenger train, with an AEM-7 locomotive at the head end, is seen on the Hell Gate Bridge approach headed for Boston. This photograph, taken from the Ditmars Avenue EL station, shows the train as it crosses Twenty-third Avenue in Astoria. (Courtesy of Jim Mardiguian.)

An Amtrak passenger train crosses one of the Hell Gate Bridge concrete approach arches over a street in Astoria. In use for over a century, these arches are a permanent fixture and an ever-present reminder that trains make up part of the fabric of the New York metropolitan area. (Courtesy of John Turkeli.)

DISCOVER THOUSANDS OF LOCAL HISTORY BOOKS
FEATURING MILLIONS OF VINTAGE IMAGES

Arcadia Publishing, the leading local history publisher in the United States, is committed to making history accessible and meaningful through publishing books that celebrate and preserve the heritage of America's people and places.

Find more books like this at
www.arcadiapublishing.com

Search for your hometown history, your old stomping grounds, and even your favorite sports team.